Oil Painting
The Workshop Experience

FULL SUNLIGHT
Oil on panel, 11″ × 10″

Oil Painting
The Workshop Experience

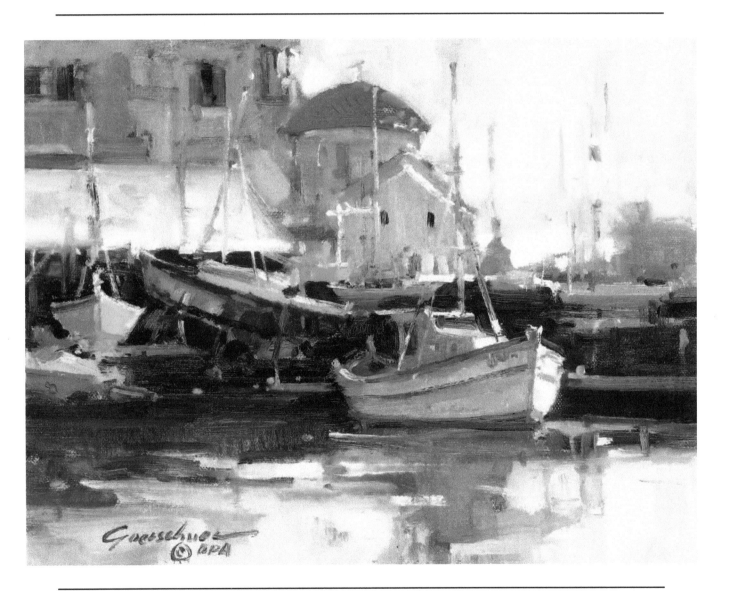

Ted Goerschner with Lewis Barrett Lehrman

ECHO POINT BOOKS & MEDIA, LLC

ABOUT THE AUTHORS

TED GOERSCHNER

A devoted oil painter and teacher, Ted Goerschner resides in Santa Ynez, California, where he shares a home and studio with his wife, well-known watercolorist Marilyn Simandle. Ted has been a full-time professional artist for over forty years, making his home in places as widely diverse as New England, New York, Florida, Arizona and California, working in a constantly growing and expanding succession of media and styles. Recipient of both the 1996 and 1997 "People's Choice Award" given at the National Oil Painters of America shows, Ted's work is featured at Lagerquest Gallery, Atlanta, Georgia; Greenhouse Gallery, San Antonio, Texas; Gallery Gabrie, Pasadena, California; and Zantman's Art Gallery, Carmel, California.

LEWIS BARRETT LEHRMAN

Lew Lehrman is a professional watercolorist, teacher and author, whose books *Becoming a Successful Artist* (1992), *Energize Your Paintings With Color* (1993), *Freshen Your Paintings With New Ideas* (1994) and *Capturing Light in Watercolor With Marilyn Simandle* are published by North Light.

He received his education at Carnegie Institute of Technology in Pittsburgh, Pennsylvania and at Pratt Institute in New York City, and he came to fine art following nearly three decades in commercial art and illustration. A teacher of watercolor since 1992 at The Scottsdale Artist's School in Scottsdale, Arizona, Lehrman exhibits his work in Scottsdale and elsewhere.

Published by Echo Point Books & Media
Brattleboro, Vermont
www.EchoPointBooks.com

ISBN: 978-1-62654-855-8

Interior book design by Sandy Conopeotis Kent

Cover design by Adrienne Núñez,
Echo Point Books & Media

Editorial and proofreading assistance by Christine Schultz,
Echo Point Books & Media

Printed and bound in the United States of America

METRIC CONVERSION CHART		
TO CONVERT	**TO**	**MULTIPLY BY**
Inches	Centimeters	2.54
Centimeters	Inches	0.4
Feet	Centimeters	30.5
Centimeters	Feet	0.03
Yards	Meters	0.9
Meters	Yards	1.1
Sq. Inches	Sq. Centimeters	6.45
Sq. Centimeters	Sq. Inches	0.16
Sq. Feet	Sq. Meters	0.09
Sq. Meters	Sq. Feet	10.8
Sq. Yards	Sq. Meters	0.8
Sq. Meters	Sq. Yards	1.2
Pounds	Kilograms	0.45
Kilograms	Pounds	2.2
Ounces	Grams	28.4
Grams	Ounces	0.04

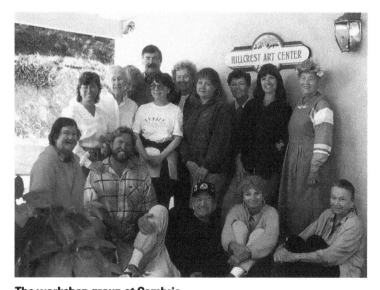

Buck, 1990 - 1994

DEDICATION

—To my loving wife, Marilyn, for her support and inspiration over the years,

—To the many wonderful people I've met and worked with at workshops from coast to coast and who share with me the same deep feelings about art,

—To Buck, a special friend who died of cancer in January 1994. Not only was he my traveling buddy and constant painting companion, but also a gentlemanly addition to every workshop. A very special dog, Buck is missed by many, but by this artist most of all.

ACKNOWLEDGMENTS

My special thanks . . .

—To Lew Lehrman for putting my words and ideas into readable English, and then organizing those words—a noteworthy task. He is a joy to work with, with a sense of humor that made this book so much more fun to do,

—To my wife, Marilyn, whose daily support helps me in everything I do, and to my parents, who never discouraged their son from his idea of becoming an artist,

—To Joe Rossi, my watercolor teacher at the Newark School, who instilled in me the burning desire to be a painter,

—To Ruth Kaspar, who runs the Scottsdale Artists' School, and to Charlotte and Ron McWhinney, owners of the Hillcrest Inn and Arts Center at Cambria, California, for graciously allowing us to record and photograph just about everything that appears on the following pages,

—To the participants in the Scottsdale and Cambria workshops, who generously allowed Lew and me to disrupt the proceedings every few minutes to take progressive photos, and then cheered me as I used their paintings for my "paint-on" critiques,

—To the people at North Light, especially editors Rachel Wolf and Kathy Kipp, for their enthusiastic help and support and for working with Lew to put all the pieces together to make this book.

—Ted Goerschner

The workshop group at Cambria
Hosts Ron (wearing the plaid shirt) and Charlotte McWhinney (standing behind him). The tall one in the back is me.

PREFACE
1

Who I Am . . . and How I Got Here
Getting the Most From This Workshop
2

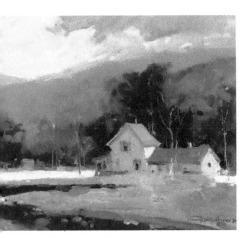

DAY ONE

The Secret of Fresh, Bright Color, 5

My Working Setup, 6
The Five Great Color Schemes, 8
The Secret of Fresh, Bright Color, 12
Graying Colors for Shadow and Distance, 14
Goerschner's Palette, 16
Start Fresh: My Basic Approach, 18
 Paint-On Critique
Notes on Technique, 26
Composition, 31

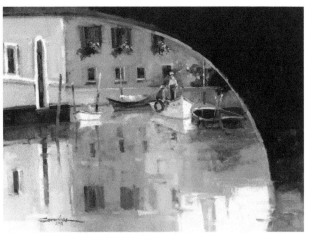

DAY TWO

Opening Your Creative Eyes, 35

Building Your Own Scene, 36
 Paint-On Critique
Transcending Your Source Material, 44
 Paint-On Critique

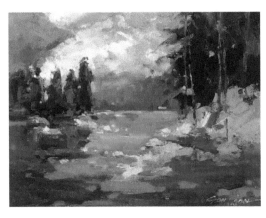

DAY THREE

Painting Under the Sky, 53

Keep It Simple . . . Keep It Fresh!, 54
 Paint-On Critique
Welcome to the Great Outdoors, 60
 Paint-On Critique
Ignore What You See . . . Paint What Works!, 68
 Paint-On Critique

DAY FOUR

Foundations for Success, 75

Five Keys to Successful Paintings, 76
Push Color to the Limit, 84

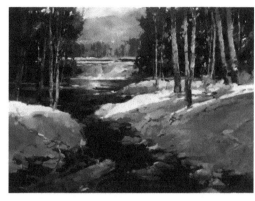

DAY FIVE

A Difficult Day at Morro Bay, 91

The One That Almost Got Away, 92
Anything Is Paintable, 100
 Paint-On Critique

DAY SIX

Adding Life to Your Paintings, 107

Punching Up the Point of Interest, 108
 Paint-On Critique
Painting a Subject With People, 112
 Paint-On Critique

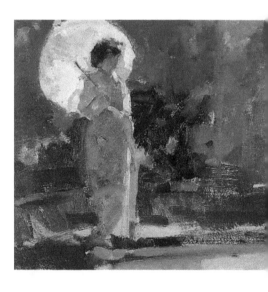

A FEW OF MY FAVORITE RESOURCES
134

A FINAL WORD
135

INDEX
136

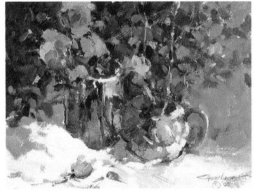

DAY SEVEN

Designing Your Paintings, 121

Think Planes and Masses, 122
 Paint-On Critique
Creating Eye Movement, 126
 Paint-On Critique

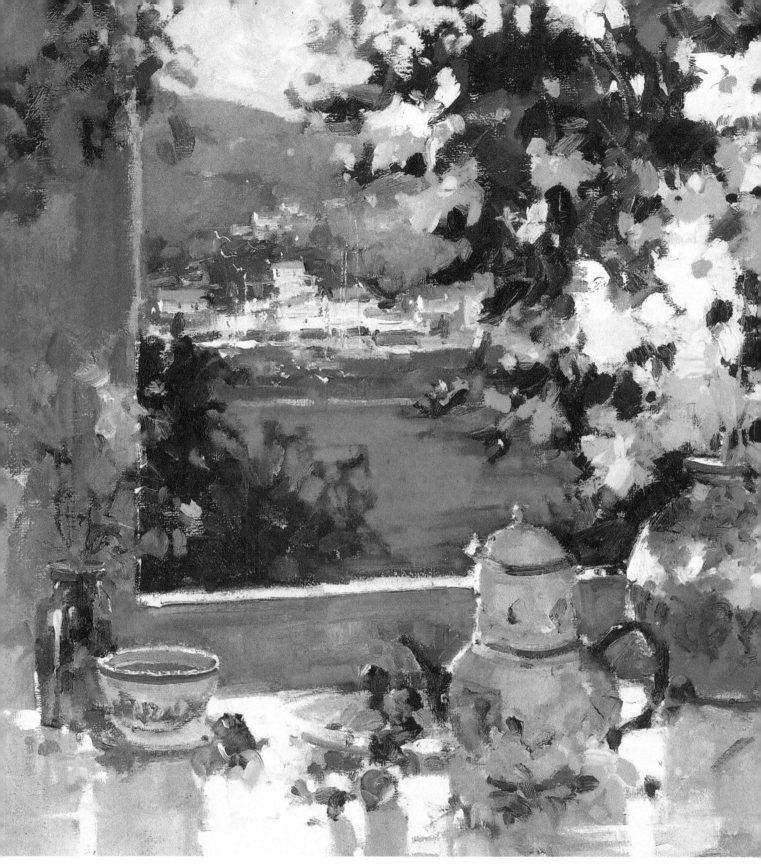

MORNING VIEW
oil on panel, 24″ × 30″

The kind of painting that makes you feel good
This was a major painting for my 1994 San Francisco show, and one of the first to be sold. That's probably because it makes people feel good—an exciting subject in an appealing setting. The floral subject was set up in my California studio, while the harbor is in Greece. The challenge was simplifying the harbor scene to avoid splitting the point of interest. Become comfortable with your painting before trying this sort of dual subject.

PREFACE

I met Ted Goerschner several years ago while taking a workshop at the Scottsdale Artists' School with his wife, Marilyn Simandle. Ted was teaching next door. I watched him do a demonstration one evening, and though a dyed-in-the-d'Arches watercolorist, I was intrigued with his fresh, bold approach to oils. How did he manage to convey so much with such economy of brushstroke and detail?

A year later, I asked him to do a demonstration painting for the book I was working on, *Energize Your Paintings With Color*; then another for *Freshen Your Paintings With New Ideas*.

One day, Ted confided that he'd always wanted to do a book, but dreaded the hassle of writing it. I realized that I could learn, as well as teach others, about his approach through our collaboration on such a project, and North Light's interest was all I needed.

We got to work on the book you're holding in your hands, which is nothing less than a seven-day, intensive painting workshop in print. At my studio, Ted painted while I interviewed, videotaped, photographed, took notes, and posed the kinds of questions to him that I knew you'd have asked. Then I sat in on his workshop at the Scottsdale Artists' School, doing more of the same.

A few months later, I flew to Santa Barbara and accompanied Ted to another workshop, this time at Cambria's cozy Hillcrest Inn and Arts Center. I spent the week trailing the group, still taping, photographing and asking questions.

Could I remain unaffected by Ted's knowledgeable and energetic approach to his medium? Impossible! Back home, I dusted off my ancient oils, invested in some new brushes, and began pushing pigment around for the first time in thirty years! Though I'm still primarily a watercolorist, Ted's universal concepts now find expression in my own favorite medium.

Read. Enjoy. Paint! You'll emerge a better artist than when you started!

—Lew Lehrman
July, 1994

Who I Am . . . and How I Got Here

The way I view it, the artist today has an obligation to try and make the world a little better place . . . to uplift the human spirit . . . to say, "Psst. Let me show you what you missed, that color . . . the light pouring out . . ." I try to create beauty in the simplest, most direct way possible.

How I got here

An artist? I never wanted to be anything else! Growing up in Union, New Jersey, before the war, I decided that's what I wanted. After high school, I enrolled at the Newark School of Fine and Industrial Art. It was a great school, with really good academic instructors who taught me perspective and basic drawing. But I was only there for a year; then I was drafted and sent to Korea.

Beginning to become an artist

When I returned home, my parents were getting ready to move to Florida, so I went with them. I took a job at a commercial art studio in St. Petersburg, where I quickly realized that I needed more schooling. I enrolled at St. Petersburg Junior College, and later at Tampa University.

My art courses were a joke. I could already draw better than any of the instructors, but I did meet a bunch of guys from New York. Cooper Union graduates, all about ten years older than me, they were commercial artists and abstract painters. In the 1950s, in Florida, abstract art was all the rage. I decided to go in with them.

Abstract art . . . a whole new world!

We all shared a studio and painted abstracts from morning to night. I learned to think in terms of pure shape, an approach that has helped me solve many problems with my paintings.

I painted with those artists from 1955 to 1960,

probably my best and most educational design years, until moving back to New Jersey in 1960 and returning to commercial art, yet still finding time to take some courses at the Art Students' League in New York City.

Exploring, evolving

My work was developing, too. I had grown out of the strictly abstract, into a designy type of realism. Calligraphic. Almost oriental. I stayed with that until about 1963, when Andrew Wyeth was becoming a household name. I was very influenced by his work, and I started painting tight, very realistic egg temperas. They sold well, however the medium was not spontaneous enough for me and I eventually returned to oils.

My next move was to Arlington, Vermont, where I bought an old farmhouse and spent my time painting, though I finally realized that to become nationally known I'd have to go where the people were. So I moved to Rockport, Massachusetts, where I opened a studio and gallery.

By that time my style was becoming softer, more impressionistic. I met Charles Movalli, who wrote an article about my work for *American Artist Magazine*, and that really got my career moving.

Eventually I moved to Prescott, Arizona, where I lived until 1985, doing several hundred paintings a year, teaching a great deal, and showing in Scottsdale and Sedona, Arizona, Santa Fe, New Mexico, and Carmel, California.

In 1985, I met Marilyn. We went out for dinner one night and never parted. That was it. We were married in 1988 and moved to Montecito, California, then to our present Santa Ynez, California, home in 1989. We share a beautiful studio building on the property, where all our painting, framing and mailings take place. With our two dogs, Jake and Pissarro, and Figaro the cat, we finally have the perfect situation. Everything flows.

What my work is all about

When you look at the artists I've been—from abstract painter to realist, to the loose Impressionist of today—it might seem like I've swung to opposite ends of the spectrum. But for me the ultimate impressionistic expression is pure abstraction; just look at Monet's water lily series. My central theme is to put down as much as I can with as little as possible, expressing it all with shape, tone and color.

About this book

Lew and I developed this book during workshops at the Scottsdale Artists' School and at the Hillcrest Inn and Arts Center in Cambria, California. I added some topics that I feel are vital to the developing artist, and we assembled all the pieces to give you the feeling of attending an intensive seven-day workshop. The result is a sequence of lessons, demonstrations and commentary that loosely follows my workshop format.

—Ted Goerschner

Getting the Most From This Workshop

One of the best things about week-long workshops is that you usually end up a better artist at the end of the week. Why not? You've spent every day doing nothing but painting, which is the best way to learn to paint.

Now, I don't mean to downplay the importance of having an instructor guiding your efforts. In fact, that's the reason behind this book. While I'm not there beside you to guide your every brushstroke, I am providing the next best thing: all my working secrets, laid out in a planned sequence of demonstrations and paint-on critiques.

A plan of action

Relax. You don't have to give this "workshop" your undivided time and attention for seven consecutive days, but let me suggest three steps that will practically guarantee an improvement in your painting skills:

First, prop this book beside your easel and paint along with me, starting at the beginning and working to the end. I've tried to provide answers to questions you might ask. Believe me, I've heard them all!

Second, take some time to study the paint-on critiques that accompany each day's demonstrations. A popular feature of my workshops, these are actual student paintings on which I pinpoint and solve the kinds of problems virtually every student struggles with.

Finally, just paint. No one gets to be a really good painter without putting miles of canvas behind him . . . but even that long journey begins with a single step. So paint as often as you can. Put my methods to the test, and they'll soon become part of your own way of working.

Let's get started!

ABOUT THE "PAINT-ON CRITIQUES"

Popular at each of my workshops are the critique sessions I refer to as "paint-ons." I take a student piece and, working right on it, try to solve some of the problems that may have stumped that student. Included here are over a dozen "paint-ons" from these [and other] workshops. I think you'll find them relevant . . . even exciting . . . because they deal with the kinds of problems just about every artist faces.

Welcome to my workshop!

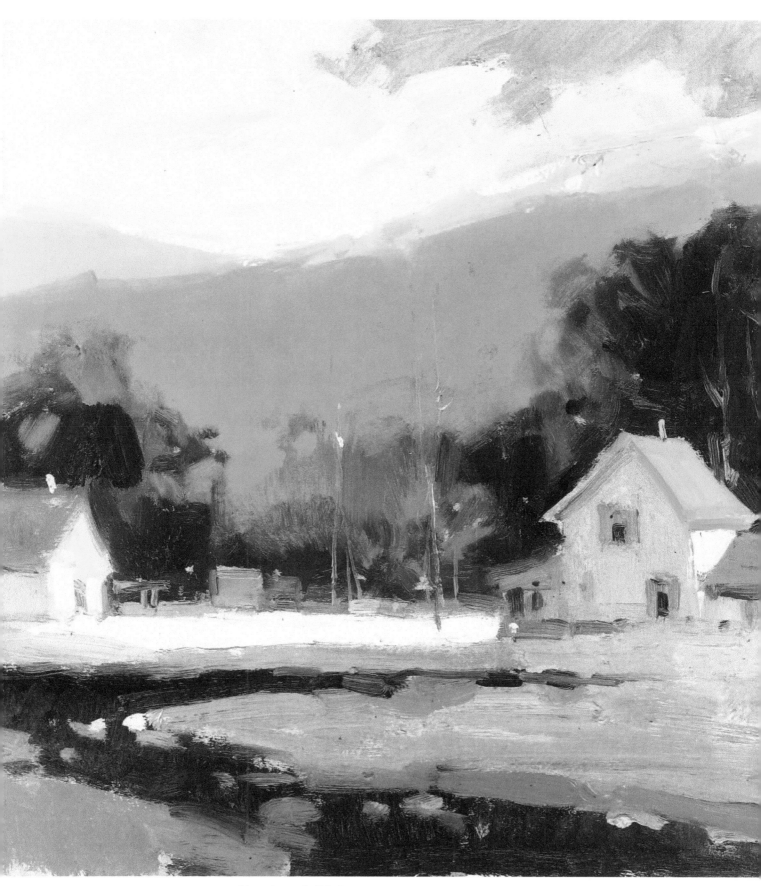

EVENING GLOW
oil on panel, 12″×16″

Very dramatic lighting
You sometimes see this kind of effect very early in the morning in the Sierras, when the light streams over the mountains. Here my light is low from the right, striking the top of the mountain at left and illuminating its entire surface. The foreground is still in cool shadow, contrasting against the warmth of the rising sun. I pushed my color quite a bit. I do enjoy getting as much impact from my color as possible.

The Secret of Fresh, Bright Color

Beginning artists often start with a palette full of paint . . . and not the slightest idea how to mix the colors they want! It's as if they're sitting at this wonderful piano, not knowing what kinds of sounds will come out when they hit the keys! When a beginner finds a good color, it's usually an accident!

Today I'll tell you about my color-mixing system, demonstrate some of the important principles underlying my approach to color and value, and explain how mixed grays are used to unify a composition.

My Working Setup

Now I'll explain my working setup. More information about equipment and materials is found near the end of this book.

In the studio

Back in Santa Ynez, Marilyn and I share a big, light-filled studio building just a few yards away from our house. The main room is where we each have our easels and working materials. A separate room serves for paperwork, packing, framing and storage.

My studio easel is a big, antique crank-adjusted affair, and for a palette I use an old four-foot-long enamel top mounted on a dresser. It gives me plenty of room to set out pigments and mix colors.

On the road

Traveling, I take my favorite folding Russian easel, pictured here. It's not as elegant as the popular French easel, but I find it sturdier and less subject to wear and tear. Also pictured here is my traveling palette. Marketed as the "Easel Pal," it comes in two sizes; I use the larger one. The two wings are great for holding brushes, and they fold up for traveling. I've lined the pigment-mixing area with a sheet of Plexiglas, which cleans up quickly and easily.

As I work, I often stop to remove paint from my mixing area with a razorblade scraper, dulled so it won't dig in. That paint is not wasted, but deposited on the side for use in remixing my four grays (which I'll get to shortly). See page 134 for more information about my favorite materials.

Squeezing out pigments

My colors are laid out beginning at lower left with four earth tones: yellow ochre, raw sienna, burnt sienna and terra rosa. They're a separate group. From that point on, I proceed in spectrum order, with cadmium yellow medium, cadmium orange, cadmium red light, cadmium red medium, alizarin crimson, manganese violet, magenta, ultramarine blue, cobalt blue, cerulean blue, viridian and sap green. Sometimes I may add another color or two, such as Indian yellow, if there's room. A large gob of titanium white at lower right and a squeeze of ivory black at upper right complete my array. Inside the arc of colors you'll see my four grays, which are described on pages 14 to 15. Though my studio palette is much larger, its arrangement is the same.

Two favorite painting surfaces: primed panels . . .

For most of my smaller paintings, up to about 20″ × 24″, I prefer to work on canvas board, or on ¼″ luan mahogany panels, which I have the lumberyard cut from 4′ × 8′ sheets. The luan is lighter and stronger than Masonite.

I prepare these panels on their smooth side with two coats of latex exterior white primer, which has a wonderful "tooth" and soaks up my initial ground beautifully. I much prefer it to gesso.

. . . and mounted canvas

For my gallery work, I use a good-quality linen canvas, such as Fredrix Carlton Single Primed Belgian Linen, which I buy by the roll and mount to unprimed panels as follows:

I cut rectangles of canvas, about half an inch larger all around than the panels. I spread a panel with an even, thin layer of a white resin glue, such as Elmer's, and lay the canvas on it, primed side up. I smooth the surface to chase out any air bubbles, then place the panel face down on the floor and walk all over it to make sure I have a tight, even glue bond. I immediately trim away the excess canvas with a mat knife, then leave it to dry thoroughly for a day or so.

Whether primed or canvas-covered, these panels are wonderful working surfaces. They're lightweight and take paint beautifully, for a fraction of the cost of commercially prepared panels.

Painting large

For paintings 24″ × 30″ and larger, I usually work on canvas stretched on heavy-duty stretcher bars, with cross-bracing for the largest sizes. I generally prefer Fredrix Carlton Single Primed Linen canvas. However, the coarser weaves are sometimes preferable, depending on subject matter and size.

In the act . . .

I paint with paper toweling in my left hand and a coffee can about one-third full of mineral spirits behind my palette. I'm constantly cleaning my brush after almost every stroke or passage.

YOUR MIXING SURFACE

Avoid mixing your colors on a white surface, because they often look entirely different—and wrong—when laid onto a toned panel. Your mixing surface should be the same value as the ground you're painting on. If you use a sheet of glass or Plexi, back it with a neutral hue.

The Five Great Color Schemes

The color wheel again?

Bear with me. It's worth your time.

Here's the color wheel. Although color transitions are actually continuous around the wheel, I've divided it into twelve segments for ease of reference: three primaries, three secondaries and six tertiaries between them. Imagine that they are brightest around the rim, and grayed progressively toward the hub, which is neutral gray. Theoretically, every pigment is located somewhere on the wheel.

The three *primary colors* are red, yellow and blue.

Secondary colors are orange, green and violet, each created by blending two primaries.

Tertiary colors are each created by mixing a primary and an adjacent secondary color.

Time out!

Rummage around for a painting you've done where you feel that the color is not "right." Prop it up beside you and read on.

Tape a scrap of clear plastic or tracing paper over the color wheel, and draw little circles on it to coincide with each color you see in your painting. Where there's a great deal of one color, make that circle BIG. If it's just a highlight, make it small.

Finished? Where are the dots? All over the wheel, completely at random? If so, your problem is disorganized color.

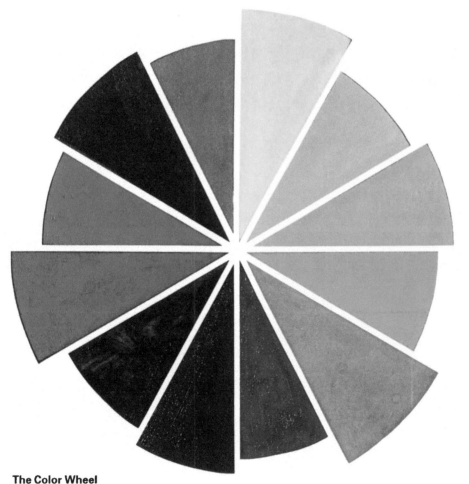

The Color Wheel

The five great color schemes

Most successful paintings are *based on one of the following five basic color schemes*!

1. MONOCHROMATIC

Monochromatic means that the entire painting is organized around just one of the colors on the wheel, using different values of that color. *Value* is the relative lightness or darkness of a color and is not that hard to learn. Draw or paint your subjects with just one color, lightening by blending with white, or darkening with neutral gray or black. Do that long enough, and you'll begin to understand how value works and why it is one key to making successful paintings.

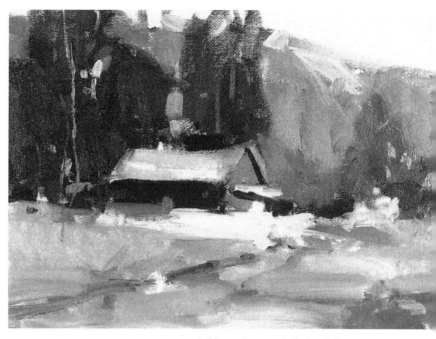

1. Monochromatic Color Scheme

I've started by mixing viridian with violet to produce a chilly, muted, dark green that will be my "mother color." I can lighten my mixtures with white or darken them with more of the mother color. The painting is nothing more than a value breakdown, not that different from a pencil rendering.

Look how well this approach suits a winter landscape. Wouldn't it be great to use for a foggy morning scene? There are eleven other colors on the wheel and a zillion variations to experiment with.

2. ANALOGOUS

Analogous means "nearly the same, or similar." In theory, this color scheme utilizes colors beginning with a primary and moving about three intervals in either direction on the color wheel. In practice, it often begins anywhere and might stretch as many as five or six intervals.

This little sketch uses yellow, yellow-orange, orange and red-orange. Alizarin crimson and burnt sienna provide my deepest values. Even with these similar colors, I can do a full-value painting. Wouldn't this be great for an autumn-in-Vermont scene? Can you imagine the impact of a small figure in this landscape wearing a complementary cerulean blue shirt?

How about trying a cool analogous series—say, blue-violet, blue, blue-green and green—for a seascape? Or violet, blue-violet and blue for a frosty winter scene?

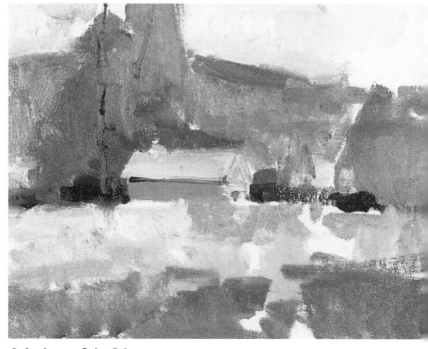

2. Analogous Color Scheme

3. TRIADIC

Triadic color schemes are based on three colors spaced more or less evenly around the color wheel. Now, this doesn't give me free license to throw in every color on my palette. I build my hues out of the selected triad. These could be high-chroma colors like cadmium yellow, cadmium red medium and cobalt blue. Or I might select a more muted triad of burnt sienna, yellow ochre and ultramarine blue. Subtle. Throws a whole different light on the triad, doesn't it?

Your selection needn't even be a *primary* triad. This little oil sketch employs a pleasant color scheme consisting of cadmium orange, viridian and manganese violet. Three *secondary* colors!

See how the yellow-greens (cadmium orange and viridian) contrast against the violet? There's violet darkening the viridian of the large tree mass, too. Also notice the use of great masses of neutral tones and just an accent of orange to draw attention.

Never use equal quantities of each color, because you'll lose your dominance and subordinance. Personally, I prefer more neutral tones with fewer high-key passages. That way, the high-key passages have greater impact.

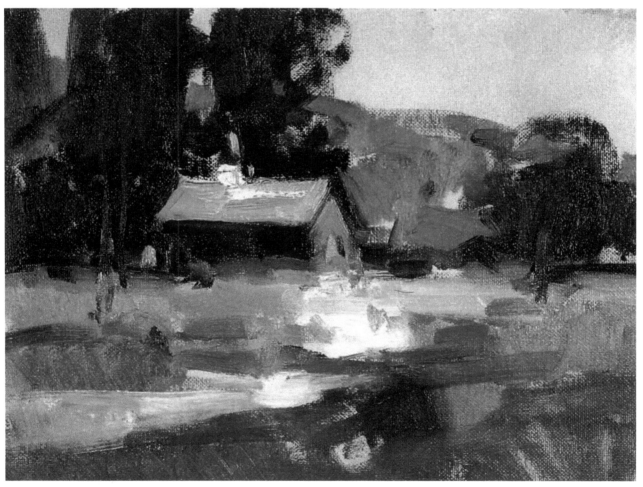

3. Triadic Color Scheme

4. COMPLEMENTARY

Complementary colors are directly opposite each other on the wheel. Color contrast is at a maximum. Experiment with any of the six different complement pairs. For example, you might try ultramarine and burnt sienna, violet and yellow ochre, viridian and cadmium red medium.

In this color sketch, based on red against green, I've painted my barn in red tones. The neutral roof is a mixture of both. I've mixed

4. Complementary Color Scheme

viridian and sap green with cadmium orange for warmer greens, and viridian with burnt sienna for cooler tones. The sky is a light value of viridian. Look at how many greens I can get with just these colors!

In a complementary scheme, as in *any* color scheme, there have to be dominant and subordinate colors, just as with masses and values. Here the predominance of green makes red accents stand out.

5. SPLIT COMPLEMENTARY

With this scheme, instead of choosing the complement of the first color, shift to *the two colors adjacent to the complement* on the wheel. For example, start with yellow, instead of violet, and use blue-violet and red-violet. Got that?

Now it's your turn

Look at the five oil sketches once again. All appear unified in their use of color. Why? *Because each painting faithfully follows a particular color scheme!* Do some loose twenty-minute color sketches utilizing

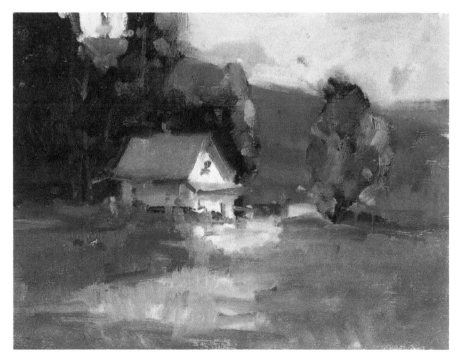

5. Split Complementary Color Scheme

these five basic color schemes. Save them for future reference. Working within a predetermined scheme can freshen and unify your paintings.

The Secret of Fresh, Bright Color

If there's one thing all of my paintings have in common, it's this: My colors are fresh and bright. That's no accident, either. All my artistic life, I've sought out and experimented with countless color theories and approaches.

This way lies muddiness

This statement has been taught to so many generations of artists, in countless workshops and classes, that it is accepted by many as an article of faith: *"To neutralize or darken a color, add its complement. To highlight, add white."* Painting an apple? Shadow the red by adding its complement, green. To highlight, add white. The green-red mixture moves the resultant color toward gray, or even black. White lightens it. Those green-red mixtures can turn dark and muddy. Adding white will often result in a flat, chalky appearance.

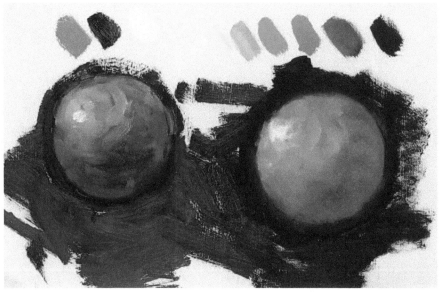

Traditional vs. analogous
On the left, shadows were created by mixing sap green with the cadmium red medium local color of the ball. Highlights were created with white. At right, the same ball shadowed with alizarin crimson and manganese violet, and highlighted analogously with cadmium red light, cadmium orange and white.

Analogous colors—another way to say apple

Back in the nineteenth century, artists were just beginning to become acquainted with the bright, bold colors handed to them by the new science of pigment chemistry. The Impressionists began to experiment with new ways of portraying color and light. Here's our painterly colorist contemplating his apple: "Why darken that apple *across* the color wheel toward its complement, leaving me with dull and lifeless neutrals, when by moving *around* the color wheel, I can achieve a shadowed value while maintaining vibrant color?" Starting with local color, say cadmium red medium, our Impressionist grabs his brush and begins to darken it with . . . alizarin crimson! Even darker with manganese violet! Encouraged now, the artist highlights the opposite side with cadmium red light, cadmium orange, cadmium yellow! Suddenly that apple explodes with color.

Tree masses

The picture at right shows the left tree mass painted with green, shadowed with *complementary* reds and highlighted with white. Compare it with the tree mass on the right. Starting with that same green, I've shadowed my tree mass *by moving analogously around the color wheel* using only my high-chroma spectrum colors: viridian, cobalt blue, ultramarine blue and manganese violet. I've highlighted its sunlit side with the cadmium yellows and just a bit of white. What a difference!

Here you have the entire secret of my bright, bold color. Shadow *analogously* around the color wheel instead of *complementarily* and you'll end most, if not all, of your "mud" problems. Lighten your colors analogously too. When you highlight this way (lightening green by going up the color wheel toward yellow, for instance) instead of with white, you'll avoid the "chalkiness" that afflicts the work of many beginners.

Now you can see why my palette is set up the way it is, allowing me to highlight and shadow intuitively, right from the palette surface. Throughout the following pages, you'll see these principles at work.

"That's great," you may be saying, "but I've looked at your paintings, and not every brushstroke is a high-chroma spectrum color. How does that fit in?"

I'm glad you asked! Please read on.

Tree masses both ways
The tree mass on the left has been shadowed with cadmium red mixed into the viridian and sap green local color. Highlights are also handled in the traditional manner. These colors are OK if you want that subdued, quiet effect. I prefer a brighter, more vibrant look. The right tree mass has been shadowed analogously with cobalt blue, ultramarine and magenta, and highlighted with cadmium yellow medium, cadmium yellow light and white.

Graying Colors for Shadow and Distance

My four grays

When I have my tube colors laid out, I complete my working palette by mixing my four working grays. You can see them around the center of my palette at right and pictured here. These are my starting grays. As I go, I'll continually scrape paint from my palette and mix it together, arriving at other, similar grays. The hues may vary along the way, but they'll stay in the same general color and value range. These grays can be combined with any of the colors on my palette to cool the warm hues or to distance the dark ones.

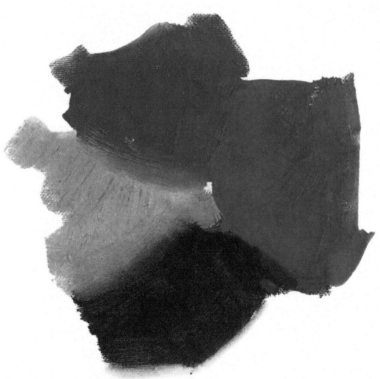

Goerschner's grays
At top-left is middle-value blue-gray, *mixed with cobalt blue, ivory black and white. At bottom is* middle-value warm gray, *mixed with cadmium orange, cadmium red light, burnt sienna and ultramarine blue. On the right is* middle-value violet-gray, *mixed with white, cobalt blue and manganese violet. At middle left is* light-value neutral gray, *mixed with titanium white, burnt sienna and ultramarine blue.*

Take out your paints and palette knife

Here are a couple of easy exercises that will give you a working knowledge of every color on your palette. I know what you're thinking. Some of my workshop students don't like to take the time to do these either. But if you do work all the way through the exercises, you'll end up with (1) knowledge of how to mix almost any color and (2) a great set of color charts for handy reference. A double dividend!

Exploring warm, light-value hues

Using a palette knife, mix cadmium yellow with light, neutral gray. Lay down a swatch ¾" square. This is not necessarily darker than the pure color. This is a *distance hue*. It simulates *atmospheric perspective*—that graying effect on objects as they recede. When you have that, take titanium white and break down the grayed yellow. Touch cadmium yellow at top as reference.

Mix blue-gray with cadmium yellow to create the swatch below the first. See how it becomes almost green? Cadmium yellow with violet-gray produces shadow tones. And look at the hues produced with warm gray.

Carry this through using warm-light colors from cadmium yellow through alizarin crimson.

Exploring cool, dark-value hues

Lay in my grays again, and demonstrate with sap green, viridian, cerulean blue, cobalt blue and ultramarine blue. These colors move into the distance when mixed with blue-gray and violet-gray.

Make a notation over each column as to the color used. Take these panels along when you paint.

Warm, Light Hues

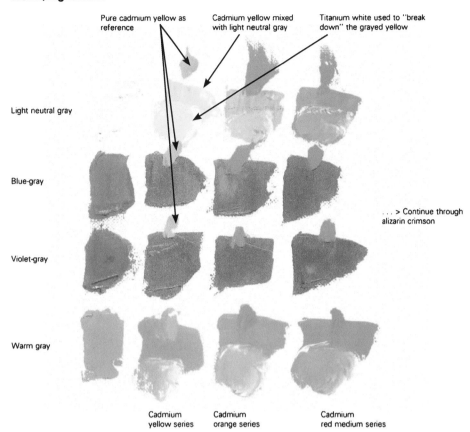

Pure cadmium yellow as reference

Cadmium yellow mixed with light neutral gray

Titanium white used to "break down" the grayed yellow

Light neutral gray

Blue-gray

Violet-gray

Warm gray

. . . > Continue through alizarin crimson

Cadmium yellow series

Cadmium orange series

Cadmium red medium series

Cool, Dark Value Hues

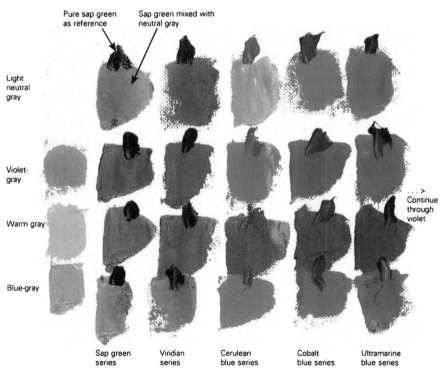

Pure sap green as reference

Sap green mixed with neutral gray

Light neutral gray

Violet-gray

Warm gray

Blue-gray

. . . > Continue through violet

Sap green series

Viridian series

Cerulean blue series

Cobalt blue series

Ultramarine blue series

Goerschner's Palette

Four Earth Tones

terra rosa
burnt sienna
raw sienna
yellow ochre

Spectrum Colors

cadmium yellow-medium
cadmium orange
cadmium red light
cadmium red medium
alizarin crimson
manganese violet
magenta
ultramarine blue
cobalt blue
cerulean blue
viridian
sap green

Black and White

ivory black
titanium white

Goerschner's Grays

**Middle-Value
Blue Gray**

titanium white
cobalt blue
ivory black

**Middle-Value
Violet Gray**

titanium white
cobalt blue
manganese violet

**Middle-Value
Warm Gray**

titanium white
cadmium orange
cadmium red light
burnt sienna
ultramarine blue

**Light-Value
Neutral Gray**

titanium white
burnt sienna
ultramarine blue

TERMS TO REMEMBER

The following terms are a sort of "shorthand" for expressing important ideas or concepts. Get to know them, if you don't already.

Abstract. Form or forms not having recognizable subject matter. The shapes exist as objects in their own right, contrasting, harmonizing and balancing with each other to make up the composition. Though I do paint recognizable subjects these days, I paint them first as abstract shapes, which helps get the composition to work.

Calligraphy. For our purposes here, this term refers to the fine linear brushstrokes you'll often see in my paintings, representing distant tree trunks, middle-ground tree branches, sailboat masts and such. These elegant little strokes add rhythm and give the eye something to focus on amidst all that bright, impressionistic, broad brushwork.

Center of Interest. Sometimes called point of interest, or focal point. The place on the painting where the viewer's eye ultimately arrives. In reality, this should be a painting's main subject, and everything else in the piece should emphasize it.

Chroma. The brightness or intensity of a color. Cadmium red straight from the tube is an example of a high-chroma color. Add gray, or the color's complement (viridian, for instance), to it, and the chroma can be gradually reduced until the resultant mixture becomes a neutral gray.

Complementary Colors. Colors opposite each other on the color wheel that produce a neutral color when combined in suitable proportions.

Contrast. Any difference between elements. A maximum color contrast, for example, exists between complementary colors, such as red and green. Value contrast exists between darks and lights, such as black and white. Masses can also contrast against each other in shape and/or size. Textures might contrast—rough versus smooth. Of course, there are infinite ways of combining contrasts.

Dominant and Subordinate. Degrees of importance applied to elements of a painting or design (might apply to any of those mentioned above in regard to contrast). Elements in a painting should rarely be of equal importance; one should always be stronger (dominant), the other weaker (subordinate). With equal importance, the viewer's eye doesn't know where to look first, resulting in confusion.

Form. The shape and structure of a given element in a painting, defined by its colors, textures and outlines.

Hard Edge. A sharply defined boundary line between adjoining areas.

Harmony. A pleasing arrangement of elements in a painting, achieved through the effective use of color, composition and value.

Local Color. The actual color of an object, which may be varied in a painting according to how the object itself is shadowed or lit, as well as by what other colors are reflected in it.

Lost-and-Found Edges. Alternating hard and soft edges along the line where two elements adjoin (such as along a mountain ridge against the sky). Intriguing to the eye, they encourage the viewer to mentally complete the indistinct portions, thereby creating real involvement with the painting.

Positive and Negative Space. Positive space is the area containing subject matter. Negative space is that not occupied by subject matter. The easiest way to understand this is to visualize a figure with hands on hips. The positive element is the figure itself. The two triangular areas between arms and body, as well as the entire area around the figure, are negative space.

Value. Degree of lightness or darkness. Light colors are said to be high value. Darks are low value. Yellow is by nature, for example, a high-value color. A single-value drawing, such as one rendered in charcoal, is based upon differing values.

Start Fresh: My Basic Approach

Point of departure

I'd like to show you some of the ways I put together and unify a composition. I'll demonstrate some of the important principles underlying my approach to color, value and form.

Problems and solutions

Take a look at the photo I'm working from and the problems I want to solve. The great dark tree mass at left center will be my dominant form, though *not* the center of interest. That will be determined, at least in part, by the area with the strongest contrasts, brightest colors and hardest edges.

The large tree mass at left center will be a subordinate area, with closely related values (darks and lights will not be too contrasty). The edges here will be much softer. I don't want this element to draw a lot of attention, but to support the lighter tree mass at right. The roadway will become a natural entry into the painting.

Many artists get into trouble by keeping all the snow the same value when painting a snowscape. My highest-key snow will appear in the center of interest. The rest will be two or three values down.

Step 1. Blocking in masses

Kill the white surface by wiping on some violet-gray. Any fairly neutral tint is OK, so that when you lay down whites, you can see how they work. I hit the dominant mass first, focusing on form and shape.

My point of interest is the tree mass at lower right. Naples yellow, viridian and sap green give me a green I like. A half-inch flat bristle brush held at an angle to the canvas is used to scrub in large shapes. The sides of the bristles are seeing more action than the tips.

Stay conscious of the negative areas—the spaces between the masses. At this point, my painting is still almost completely abstract. I'm sensitive to shape, even at this early stage.

LOOK FOR THE BIG SHAPES

It's important to block in forms at the outset, keeping them very abstract. Squint at your subject and look for the big shapes. I don't even think of subject matter at this stage. Get at the essence of the composition: shapes and masses.

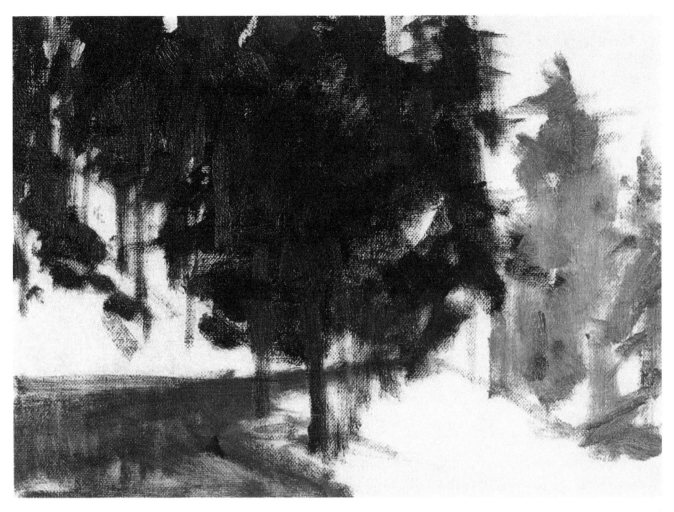

Step 2. The image emerges

I block in the roadway mass. A dark, warm gray blended from my blue-gray with burnt sienna does nicely. Now I can add some "calligraphy," as I call it: those linear elements that give rhythm and interest to a painting. Here, tree trunks against the snowy hillside.

I'm still thinking of negative spaces. Look at these tree trunks from left to right: heavy positive, thin negative, medium positive, medium negative, thin positive, wide negative and so on. I want to keep that interesting, varied rhythm. I lay in some trees at foreground center, just to break up the sweeping motion of the roadway, completing my block-in.

KEEP IT FRESH

I try to keep my paintings fresh by not going over an area any more than I have to. If the value, color and shape are right the first time, I let those brushstrokes stand—right to the finish.

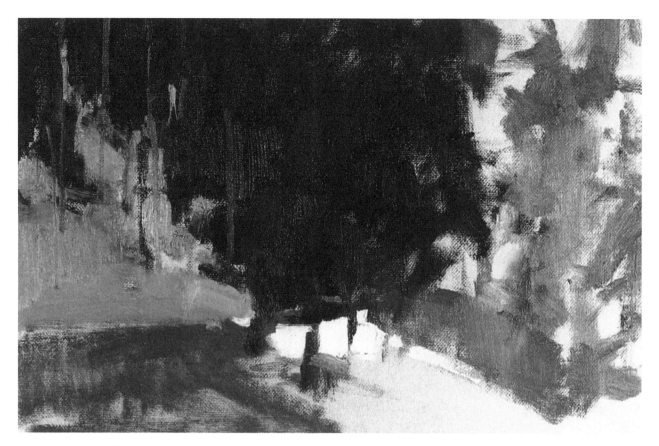

Step 3. Adding color

Let's start with some color now. I can see a hint of lavender in the bushes at right middle ground. Mixing terra rosa and manganese violet gives a red-violet that's a great complement to the yellow-green above. It gives an opening to go with a really bright violet. And look at that startling yellow in the tree. For distant trees, I'll use some of my violet-gray and yellow-green to create the cool distant shapes at top right.

Now to get into the individual masses. I begin with a light blue-gray in the snow at left. I liven it up with other shades of blue as well. A little ultramarine here does the trick.

I try to keep thinking "shape," not "tree." If I were thinking "tree," I'd be putting in branches, pinecones, leaves and so on.

Brushing yellow into the greens at top center gives the effect of light coming through the trees. Light tree trunks and branches atop the dark green mass start turning my two-dimensional composition into a three-dimensional, representational painting. I use some of my warm gray thinned with a little solvent and applied with a rigger brush. Thinning makes it go down without disturbing the still-wet paint film already there. Darkest darks, greens with ultramarine blue, added between the trunks and branches help push these areas back, creating the illusion of depth.

At the bottom of the dark mass, close to my center of interest (the light tree mass at right), I place the strongest contrasts in the painting. Pure white, highlighted snow establishes dramatic contrast against the near-black of the dominant tree mass.

STAND BACK

It's best to paint standing up, if possible, in order to easily step back every few minutes and see what you've got going.

Step 4. Working within the shapes

Here's a good example of taking a two-dimensional shape and defining its three-dimensional form. I'll start working on the roadway now.

Light warm gray with raw sienna and white defines the top surface of the retaining wall; a darker warm gray made up of burnt sienna and ultramarine forms the sides. That same gray, distanced just a bit with violet-gray, also sets the vertical of the far retaining wall. With all this talk of roadways and walls, though, I'm really only breaking up a two-dimensional shape.

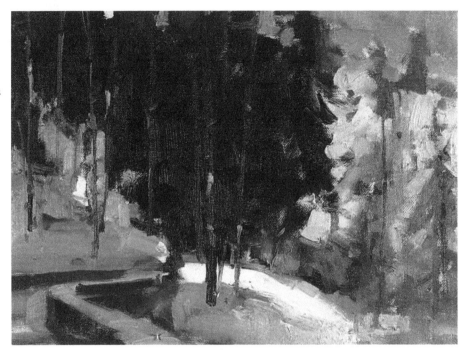

I move to the area at lower center. My blue-gray serves to shadow the snow here, and I blend it into the gray of the wall at left, with the pure white of the snow at right.

How about a touch of pure top-chroma cadmium orange? Pow! Look how that lights up this area. I touch in a couple of dots of it elsewhere in the painting. Begin to create that secondary center of interest. Sometimes, students look at that kind of color highlight and ask me, "What's *that*?" "A dumpster," I tell them. Fact is, it really doesn't matter! It's color, and color is what makes a painting exciting!

Returning to the background at top right, I remember that my highest-key whites should be reserved for the center of interest. This area can't appear as white as it did in the photo, so I use my neutral gray.

That pure white gives me a brilliant light streak across the center of interest. I can repeat it in unexpected spots, as at left, back in the trees as my secondary point of interest, darkening my tree trunks there to heighten the contrast.

I use my neutral gray with ultramarine and cobalt to shadow the foreground snow, blending it into the white highlight. A streak of cobalt and white creates a transition between the white and the violet just above it.

Touches of dark and light in the tree trunks create interest and excitement. But I always keep in mind the rhythmic balance between the negative and positive.

KEEP IT SIMPLE

You'd be surprised at what the human eye will accept. Keep your shapes simple. Most people put enough strokes in one painting to do two or three!

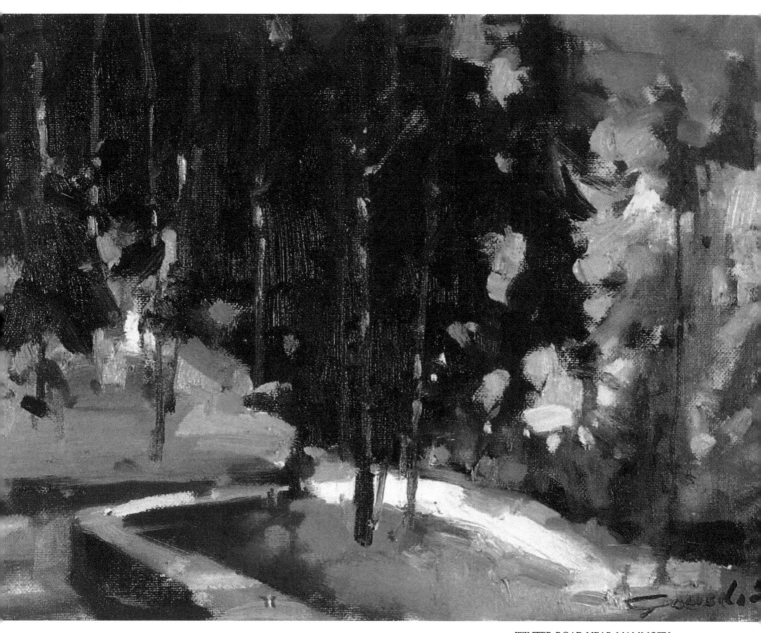

WINTER ROAD NEAR MAMMOTH,
CALIFORNIA
oil, 10″ × 14″

Step 5. Finishing touches

I correct some of the shapes, especially in the dark tree mass, breaking up the
foreground snow with some more brushwork and adding touches of ceru-
lean in the background. A few patches of broken color, some sparkling high-
lights, and the painting is done.

This piece works well, partly because the grays, which appear in the shad-
ows as well as in other areas, are all from the same family of colors. High-key
colors, as in the light tree mass, were cooled with these same grays to give
them their shadow values, while the darks were also lightened with them.

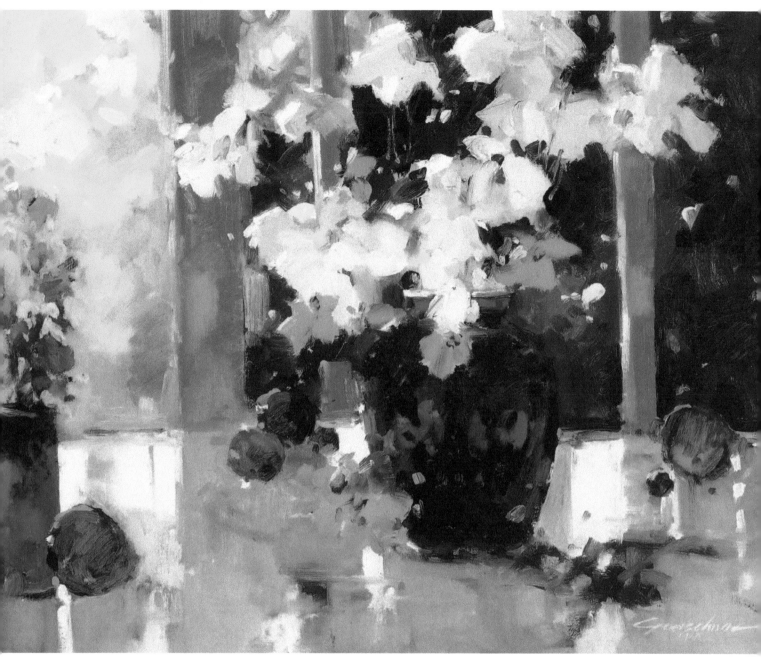

Light and shadow

Once in a while I catch everything I hoped for. This painting has the feeling of light that is exactly right. It was a setup in my studio, with light shining strongly through a window creating beautiful negative spaces, shapes and shadows. Note how the flowers are nearly all in shadow, except for little touches of white along edges, to give a backlit feeling. I find backlighting most challenging, most rewarding, because there is so much more freedom to play with the color in shadows.

LIGHT FROM THE WINDOW
oil on panel, 18″ × 24″

Paint-On Critique

The shapes here are not bad, and the overall pattern is good. What bothers me most in this painting are all the horizontal brushstrokes. The ground plane is confusing, too. It's not clear where the horizontal part of the background ends and the vertical begins. They blend together. Watch how I use my grays to shadow the snow, push the background back and unify this composition.

A R T I S T
Frances Vogel

BEFORE

Background trees just as strong as foreground trees, so they don't recede

No gradation in value to connote depth

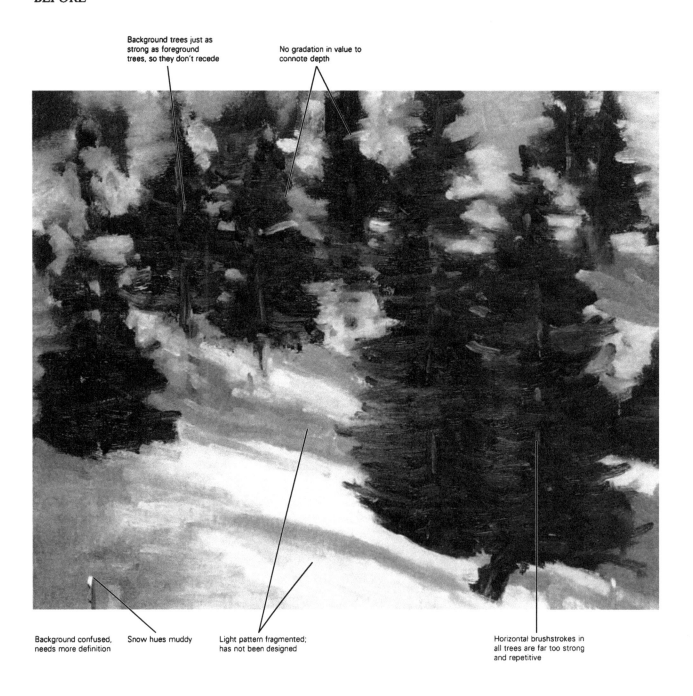

Background confused, needs more definition

Snow hues muddy

Light pattern fragmented; has not been designed

Horizontal brushstrokes in all trees are far too strong and repetitive

AFTER

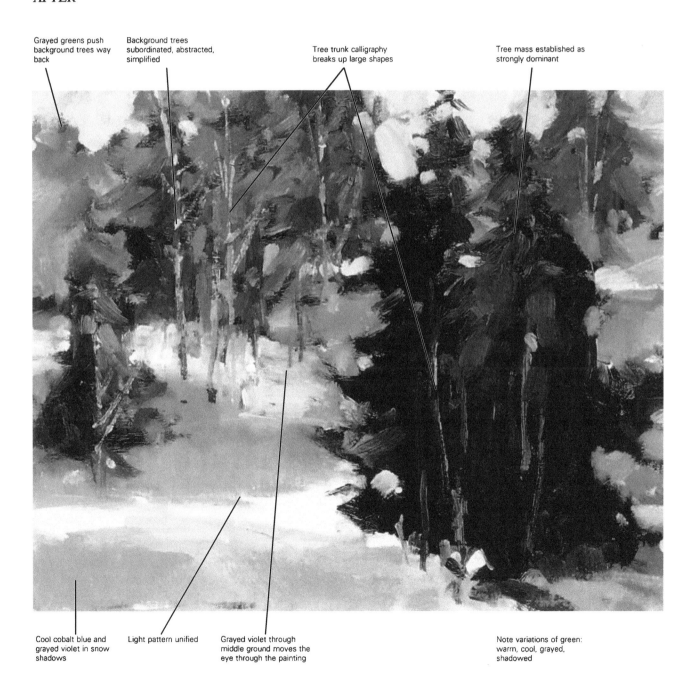

Grayed greens push background trees way back

Background trees subordinated, abstracted, simplified

Tree trunk calligraphy breaks up large shapes

Tree mass established as strongly dominant

Cool cobalt blue and grayed violet in snow shadows

Light pattern unified

Grayed violet through middle ground moves the eye through the painting

Note variations of green: warm, cool, grayed, shadowed

Notes on Technique

Brush and paint

Do you tense up when getting ready to apply each new gob of paint? Does the brush sometimes seem to be controlled by alien forces? Do you feel lost in a trackless wilderness?

Today let's begin to get acquainted with our primary working tool—the brush. My objective is to have you discover for yourself how the brush works, how oil paint behaves, and how they can both be tamed. Then you can start to free up your creativity!

My goal is to put down each stroke once, perfectly, and never touch it again. With that in mind, I put considerable effort into developing my brushwork.

Every brushstroke contains every principle of painting. If the stroke is right, it carries everything you want in one shot: color, value, shape, movement, texture.

Let's take a few minutes to talk about brushwork and how to get the paint to do what you want, starting with a few basics.

It's my belief that the beginning painter should stay with bristle brushes for oils. Save sables for more advanced techniques, such as glazing, scumbling or really fine detail. Sables don't have the stiffness needed to move paint around the way I like to.

I use four basic styles of bristle brushes:

1. *Brights* are flat, relatively short-bristled brushes. Their stiffness enables me to move a lot of paint around quickly, which makes them ideal for the starting stages of a painting.

2. *Flats* are similar to brights, but have longer bristles that give them greater flexibility. I use them most often to develop the look and feel of the brushwork as my painting gets into its later stages. Flats and brights leave a somewhat square-ended "signature."

3. *Rounds* are round-bodied brushes with fairly long bristles and pointed tips. The smaller sizes are useful for linear detail, such as branches, flower stems, etc. The larger sizes will carry a good deal of paint, but paint a narrower path.

4. *Filberts* are thick-bodied flats with even longer bristles and an elliptical end that leaves a more rounded stroke. The bigger filberts are ideal for scrubbing in large areas of color and for softening and losing edges. Smaller sizes behave almost like a round, but carry more paint.

A few of my many brushes
Some of my brushes are so worn that the tips have become rounded (these are often my favorites). The one at far right is called a "rigger." It's a long-haired, square-tipped sable that will lay down an even-width line of paint. I often use my rigger in the finishing stages of a painting to suggest branches and such.

Straight stroke
Note how I can lay down a swath of paint that's just the width of the brush.

Direct stroke
The broad end of the brush is diagonally in contact with the canvas, resulting in a much wider stroke that is different in character as well.

Chisel stroke
This stroke is much more delicate and controlled. I get my brush down to a flat edge by loading it with paint and then stroking its opposite faces against my palette surface to produce a sharp, chisel-edged end. Moving it sideways achieves a fairly fine line.

Ways to handle brush and paint

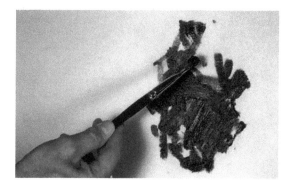

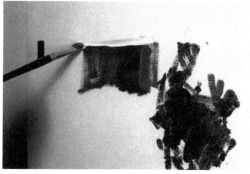

1 I grab a bright and load it with paint. It's *really* loaded, to get a large amount of paint down quickly. Follow along with me.

Notice how I'm holding my brush. This grip is comfortable, but remember that most of the energy to push the paint comes from the arm muscles, not the wrist or hand. The vigor of your arm movements is translated directly to the canvas and is immediately visible in your brushstrokes.

2 Here I've scrubbed in an element that might represent the shadowed side of a building. To achieve a highlight along the top edge, I mix a little cadmium yellow with white and lay it across the top.

PAINTING OVER A WET SURFACE

The trick to painting over a wet paint surface is keeping lots of paint on the brush, with the new layer just touching the existing layer, and not letting the bristles dig through to the canvas.

3 The dark green mass might represent background trees. With quite a bit of green on my brush, I lay that green next to the white, slanting the brush in the direction of my stroke with a minimum of pressure, overlapping the white slightly, and narrowing it as I go. Hold your hand high.

Note how some of the white has come up through the green. Sometimes I'll let that stay. Occasionally I'll make a second pass with the green to cover it, perhaps waiting a day or two until the paint film has dried.

4 Now, switching to a small filbert loaded with the sienna hue, I come back against that white line from below, narrowing it before working down into the building. Here my hand is well below the area, letting the tip bristles cut the edge, using as little pressure as possible.

5 I'll start on a fence, mixing warm gray with violet-gray. I lay this in right over the brown, because I'll paint the negative spaces—the holes in the fence—in the next step.

6 Creating the positive shape, and then coming back to lay in negative areas, is a technique you'll find countless uses for—light coming through trees, windows in houses, the centers of flowers, you name it!

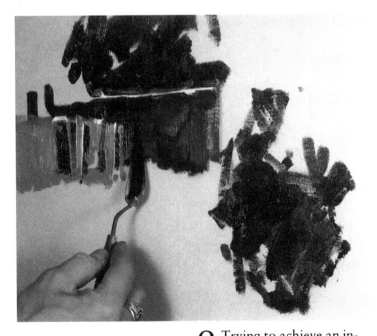

7 Here, I'm creating highlights on the top of the fence and along an edge by laying down a line of white, then coming back into it from both sides.

8 Trying to achieve an intense color over a wet paint film is often a mistake. Remove the wet paint first. I take a minute to scrape up as much pigment as possible with my palette knife.

PRACTICE PUSHING PAINT AROUND

One day when you don't feel like starting a painting, become more familiar with the physical characteristics of paint and brush. Lay paint over paint. Try narrowing a line by painting up to it. Roll the brush around. Scrub paint in, or apply it so lightly that it doesn't lift the layer beneath. Eventually, you'll learn what paint and brush can actually do and will be able to get effects at will.

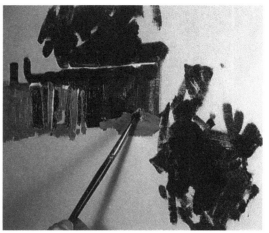

9 I paint that opening with an alizarin crimson/ultramarine blue mixture—one of the darkest combinations I can mix.

10 I use a round brush to paint light violet on top of the sienna.

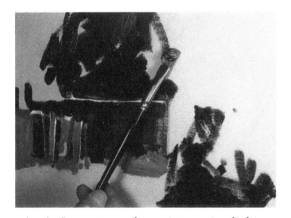

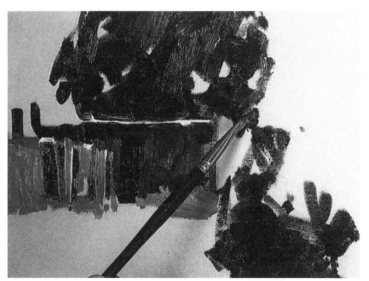

11 I want to make an interesting light side to the dark tree mass. Look how I marbleize my paint, dipping my brush into yellow ochre, cadmium orange and viridian, not mixing them on the palette, but on the canvas, though not completely.

12 Look at that effect. There's just no other way to achieve it. Experiment with marbleizing various colors. You should become familiar with this technique!

DEVELOP YOUR COLOR SENSE

Mix your paint slowly, so you get a sense of the color before committing to it. Hold the mixing knife in front of your painting to see if the color looks right. You'll gradually develop a sensitivity to the amount of paint needed to cover an area.

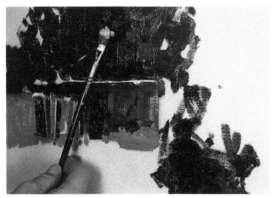

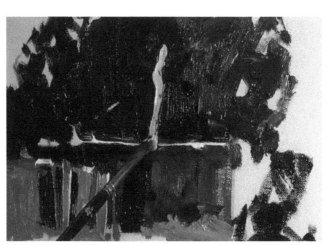

13 To add tree trunks and branches over this dark, wet paint, you'll need a lot of paint on your brush. Here's my filbert, loaded and ready to go.

14 I refer to these linear elements as "calligraphy." They add interest, tie elements together, and make abstracted subjects more recognizable. Details can be added with the rigger brush by thinning the paint with solvent. The soft, sable-type hair will deposit the paint without disturbing wet film. Or, you can wait until the painting is dry.

15 At top I've laid in several tree trunks and branches, coming back in to narrow them, breaking them up so they don't become dominant. Now to the foreground. To get the feeling of vertical bushes, load your brush and do a lot of vertical strokes, as I've done at right, leaving little holes that represent the horizontal plane. Come back in with light passages to clarify the effect.

16 Here's a final head-on shot of the exercise just completed. It's not a finished painting, just a small demonstration to start you thinking about brushwork and paint handling.

Composition

Throughout these pages, you'll see me referring to several types of pictorial composition. While I employ many different composition schemes in my paintings, I seem to come back to these few again and again. Let me briefly describe each one.

The "steelyard" composition

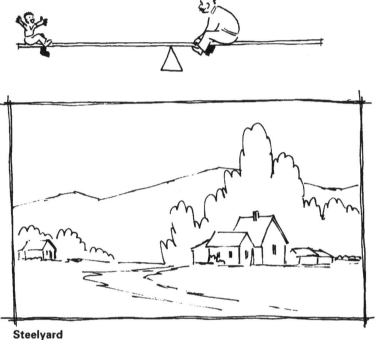

Like the large person on the seesaw who sits close to the pivot to balance the smaller person sitting as far out as possible on the opposite end, the "steelyard" (named for an artist by that name) balances a large element close to center against a small element situated far from center toward the opposite side.

Steelyard

The golden section

The golden section is a geometric ratio traditionally used in composition schemes. I have modified its rather complex formula to arrive at four optimum points of interest within a picture, which may be approximated by drawing lines to divide your panel into three equal segments both vertically and horizontally. Choose one of the four intersections as your point of interest, then plan the composition to lead the viewer's eye from that point around the canvas.

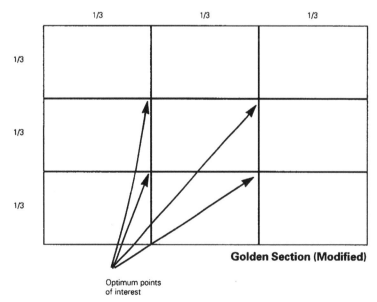

Golden Section (Modified)

Optimum points of interest

The horizontal "parallel bar"

Here, the general point of interest spreads out in a horizontal band across the painting, with the principal point of interest occurring somewhere along that line, while maintaining color, detail, etc., all the way across.

Horizontal Parallel Bar

The "tunnel"

The "tunnel" composition is quite dramatic. Foreground elements are placed to direct your eye through a gap (the "tunnel") into the middle ground or background where the point of interest is located.

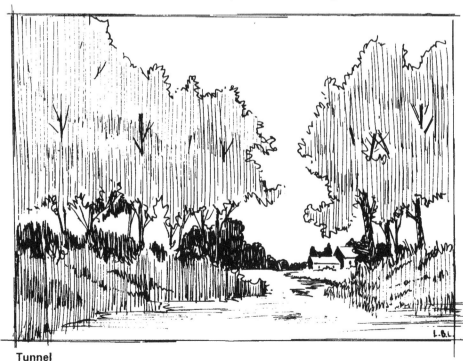

Tunnel

Elements common to most compositions

Most successful pictorial compositions have several factors in common: They have a dominant shape and corresponding subordinate shapes. They all lead the eye of the viewer into the painting through the foreground to the point of interest, which is normally in the middle ground. The background is used to enhance the point of interest.

Four Compositional Schemes

Steelyard

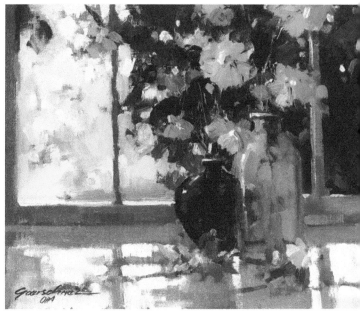

Golden Section (Modified)

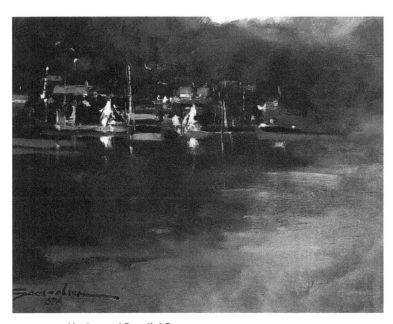

Horizontal Parallel Bar

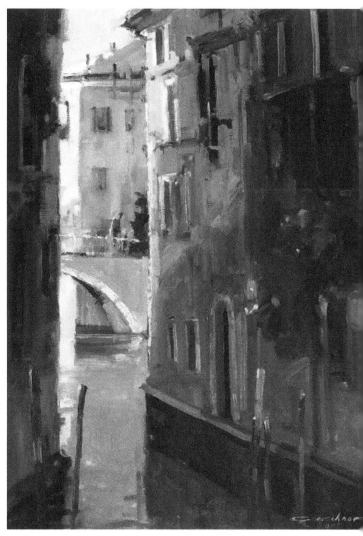

Tunnel

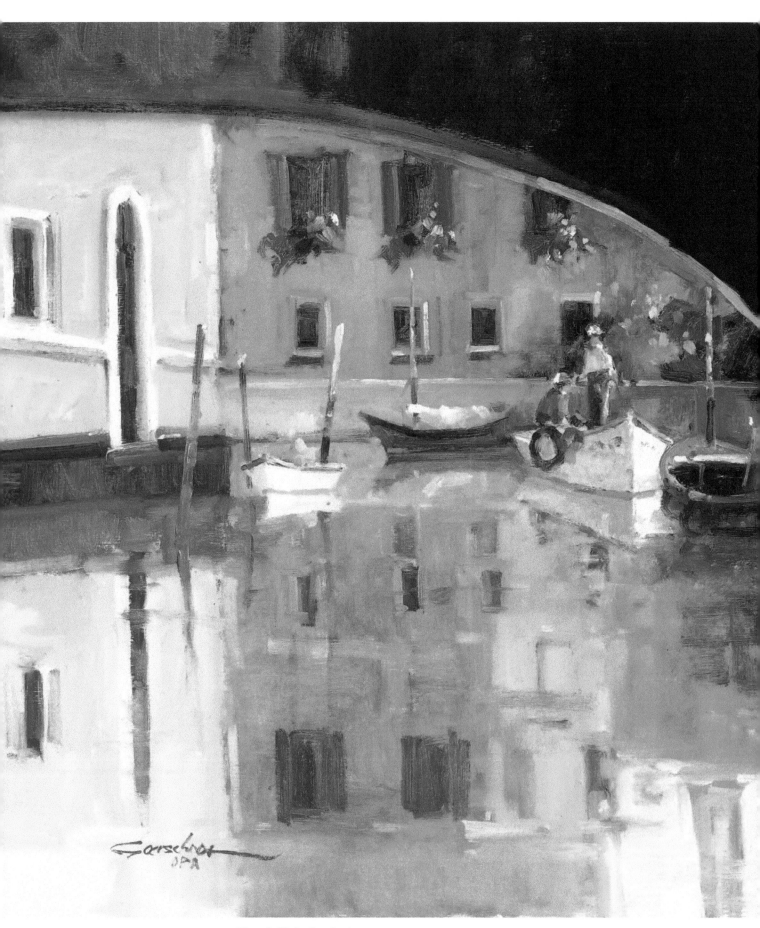

VENICE MOMENT
oil on canvas, 22" × 28"

There's life in the shadows, too
I photographed this scene from a gondola while passing under a bridge. The bridge went black in my photograph. Knowing that shadows are invariably full of color, I put modeling and color back in.

Opening Your Creative Eyes

Many people know about basic drawing and color but lack the courage and conviction to build their own painting, instead just trying to copy what they see. It's rare to find a perfect, ready-made scene out there. You have to build it for yourself.

Building Your Own Scene

Poor reference . . . poor painting?

Take a look at this photo. You probably don't see anything exciting in it, but

An exciting painting from this "nothing" photograph?

there is a painting in there. I'll show you how to pull it out and at the same time help you learn to use your source material creatively.

DON'T JUST PAINT WHAT'S THERE

Photos may fall short, but they do record the moment. Later, having been there and remembering the scene, you can plug in your own inspiration . . . which is also a good reason to *only* work from photos you have taken yourself.

Most professional painters design their work with shapes. A tree, for example, won't work as a tree through detail alone. If it isn't made up of good shapes, the artist has to *make* good shapes.

My photo has big shapes: the Grand Tetons in the background, the Snake River wandering through the valley, tree masses near and far. It may not be as inspirational as a photo, but I remember what I saw and how I felt at the moment I took it.

My center of interest, I decide, will be at lower left. Watch how I begin this piece as an abstract composition, boldly laying in large shapes with a big brush and lots of paint!

GET PHYSICAL

Get used to using big brushes and pushing paint around. Get physical with it! Oil is not a wimpy medium. It's thick and sensuous.

36

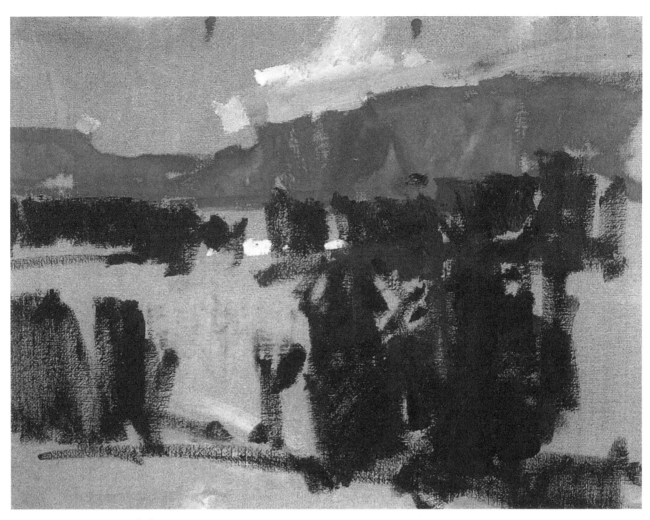

Step 1. Initial lay-in

First tone an 18″ × 24″ mounted canvas with thinned Venetian red and burnt sienna. Then begin the distant mountains, creating an interesting shape primarily through *dominance* and *subordinance*. I block in the mountains with my violet-gray mud mixture; dominant mass at right, subordinate at left.

I mix raw sienna with viridian and darken it with ultramarine blue for the distant tree line. These don't have to look much like trees, merely nice shapes that work well together.

Look at the progression of trees from left to right: big positive shape, small negative shape, small positive, large negative and so on. It's rhythmic, like music. Unexpected. Interesting.

Before painting the whole sky, I lay in a small area to test the color, a bit of light gray with cadmium orange, against its surroundings. I'm continually testing colors like this.

I scrub in foreground trees, dark with sap green and ultramarine blue, then add a stroke of pure white at center—light reflecting off the river—to see how that works. Yes!

IT'S ALL RELATIVE

Get into the habit of working all over your painting as you go, testing each color and value against its surroundings. Everything is relative. For example, you can't predict what a tree should look like until you see it *together* with the sky.

Dominant and Subordinate Masses

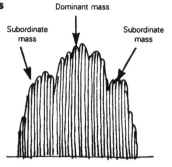

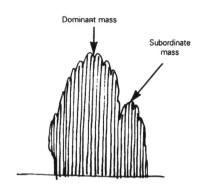

A "simple" shape. Not interest- ing.

This shape consists of one domi- nant and two subordinate masses. Better, but lacking inter- est because it's symmetrical.

This is the most interesting, be- cause it includes both a domi- nant and a subordinate mass.

Step 2. Developing the middle ground

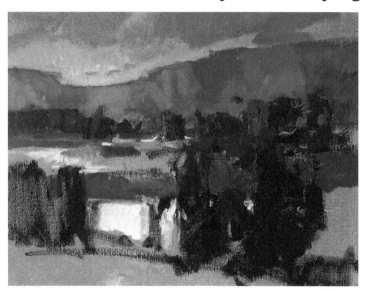

Still thinking abstractly, I begin working into my masses. The left side of the paint- ing is the subordinate side, so it will have lots of soft edges and closely related values.

I begin to work in my fields now, with greens that become more yellow toward the foreground, more violet and blue in the background. Then I thread the white of the river through the painting. I take a little time to work some color into the distant mountain, using that opportunity to nega- tively reshape the distant trees.

Step 3. Solving foreground problems

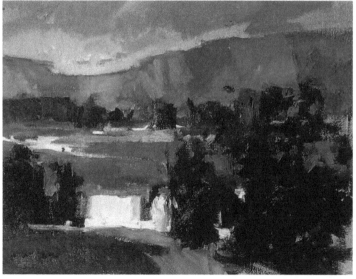

It's time to begin opening up some of the middle-right tree areas, and I'll do that by designing the shapes of my foreground trees, painting in their negative shapes. The foreground plane can't all be one color, so I vary it with blues and greens. Again, the subordinate, calm area is at left, while the dominant, ac- tive area is at right.

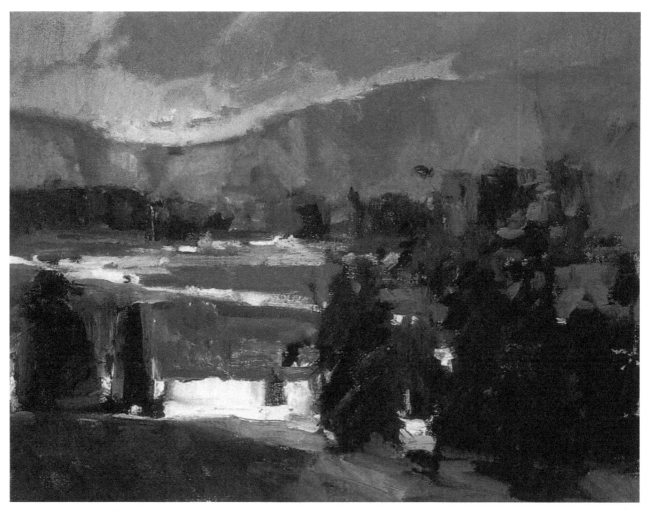

Step 4. Refining shapes and working within them

At this point, the painting is pretty well blocked in. Notice how the white shape at the foreground has become a static rectangle? Rectangles, squares and circles tend to be static. Triangles and other polygons tend to point. I alter this shape and make it move by threading it through the trees.

Now I begin breaking up my major shapes and working within them. Notice the colors in my sky, mountains, tree masses, and near and distant fields?

I bring the river in through the trees with little kisses of white. I love that.

Away from the point of interest, I lose edges here and there. See those atop the mountain at left and right? In the right foreground, I make my shadow tones quite dark with ultramarine blue and violet.

DEVELOP YOUR POINT OF INTEREST

In a pure landscape (that is, with no houses, people, animals, etc., to focus on), you have to clearly establish the point of interest with elements such as bright colors, high contrasts, sharp edges and pointing shapes.

Step 5. Getting everything to work together

I adjust my colors, pulling some lights through the trees and adding light to the sky and distant river. I also suggest some tree trunks and branches. Dots of bright, broken color here and there add excitement.

By this time, I'm so emotionally involved with the painting that I can't make logical decisions about it. Recognizing that the only mistake now would be overworking, I put the painting aside to be finished later.

DON'T WORRY

When a particular area of a painting is giving you fits, work elsewhere. The problem will often have solved itself by the time you get back to it.

SNAKE RIVER, IDAHO
oil on canvas, 18″ × 24″

Step 6. But are we being truthful?

Very few spots of color, an adjusted value or two, and the painting is ready
for my signature. Go ahead. Compare it with the original snapshot. Do you
still have trouble disassociating yourself from "reality"?

"Truth" in this, as in all of my paintings, is arrived at through what's
usually called "creative license," my interpretation of what I remember of
the scene triggered—*only started*—by my reference.

To interpret what we see before us, to distill its essence, to point out the
wonder and omit the mundane, these are among the greater truths that
make up the artist's long and honored tradition.

Paint-On Critique

This painting has several problems. To begin with, there are two points of interest: the big tree and the house. Bringing the two together will create a single strong point of interest. I'll repaint the house close to the large tree. Note how I've corrected the perspective, too. Now you see the house from straight on instead of looking down on it.

ARTIST
Rose-Mary B. Utne
Edina, Minnesota

BEFORE

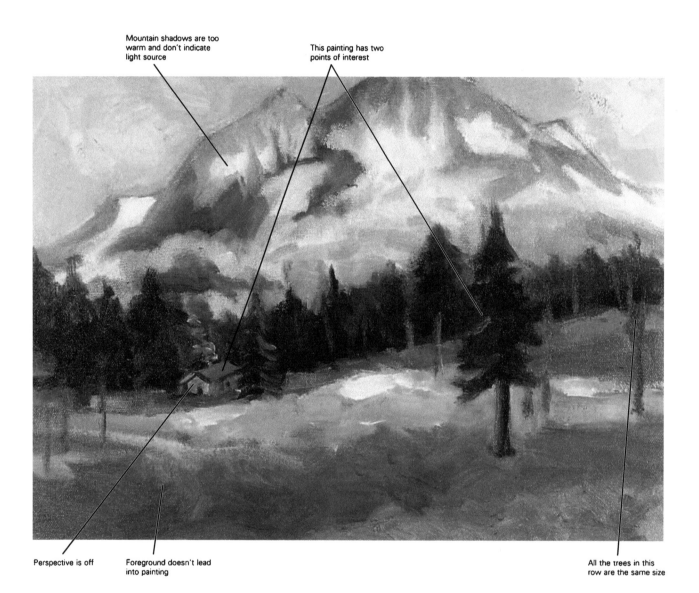

Mountain shadows are too warm and don't indicate light source

This painting has two points of interest

Perspective is off

Foreground doesn't lead into painting

All the trees in this row are the same size

AFTER

This is now the
subordinate tree mass

Dominant tree mass and
house have been moved
together to form a single
strong point of interest

Foreground shapes now
lead into the point of
interest

House shape is more
interesting

Highlighted side confirms
light source at right

43

Transcending Your Source Material

As I prepare to do a studio painting, I leaf through the huge stacks of photographs that Marilyn and I have accumulated over years of travel, knowing that pretty soon something will catch my eye. This time, I come up with a pair of photographs taken some years ago at Mammoth, California. It was winter, and I remember standing on a footbridge in a snowy landscape. Something caught my interest, and these photos were the result.

Another artist might take one look at these photographs and see nothing about them to inspire a painting. They're flat, totally monochromatic, more than a little overexposed, and each lacks a focal point. Yet they started my creative juices flowing. The memory of the forms, the calligraphy of the trees, an excitement in reflections . . . all combined to light the spark of inspiration.

Where concept begins

Source material—whether on location with the scene right there in front of me or working with photographs—is a jumping-off point. It's the *beginning*, not the completion, of my concept.

People ask me, "Why, if I'm going to change nature so much, do I need to paint outside?" The answer is that every painting needs a starting point . . . an inspiration. Ideally that inspiration should come from the source: the actual scene experienced first hand. If that's not possible, which more often than not is the case, the photographs you took will have to do.

As an artist I get to paint nature the way I feel it *should* be, not the way it is or how my camera records it! Here, nature has given me too many trees in some areas and not enough in others. The light is flat where I want brilliant snow and rich shadows. The arrangement is uninteresting instead of dynamic and exciting. Watch as I help nature along.

Starting from zero

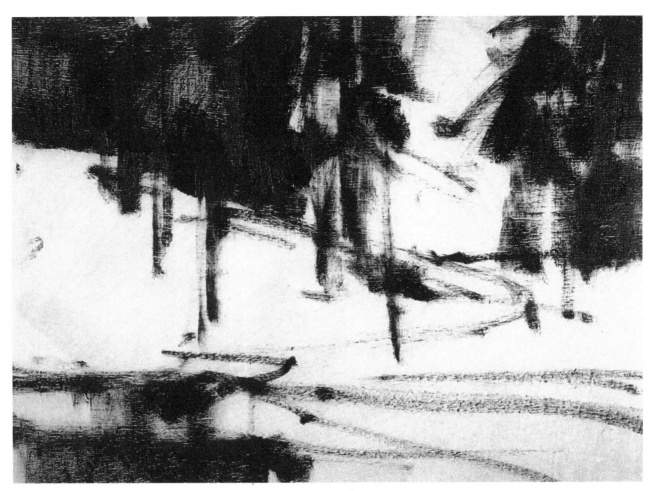

Step 1. Dive right in

This subject really excites me! I visualize my painting as a "tunnel" composition: the point of interest seen through a gap—a tunnel—between groves of trees.

I don't even take the time to tone my canvas, diving in right away and establishing my masses with a single value composed of sap green and ultramarine blue, locating dominant mass at top left and subordinate at top right, allowing for the point of interest between them. Then a few verticals for tree trunks, the stream across bottom center, and the major reflection at bottom left.

DON'T SWEAT THE DETAILS

Sometimes I wish I could tell every student, "Forget about detail for at least the next ten years. Just paint shapes!"

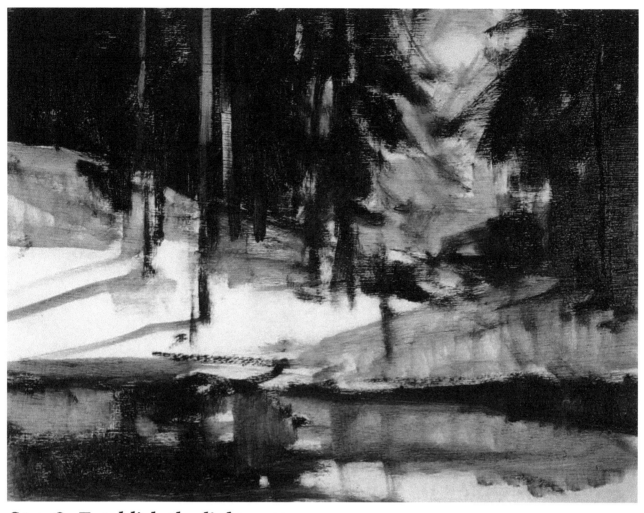

Step 2. Establish the light pattern

Continuing, I determine my light source and angle. How exciting it is to bring light in at a low angle from the rear!

I thin my dark green with mineral spirits and scrub in an oil wash of middle-value shadows to establish the light pattern. Notice how all my remaining whites are now concentrated at left foreground.

The mineral spirits evaporate quickly, and this wash is soon dry. I can work over it, without lifting, within a few minutes.

I can also remove pigment easily with a solvent-moistened brush or a bit of paper towel. I've lifted out tree trunks at upper left center using a no. 4 bright with just enough solvent on it to soften the paint film.

THE WAY IT SHOULD BE

Nature doesn't always provide you with great aesthetic shapes and rarely puts shapes precisely where you'd like them to be. An artist has to change "what is" to "what should be!"

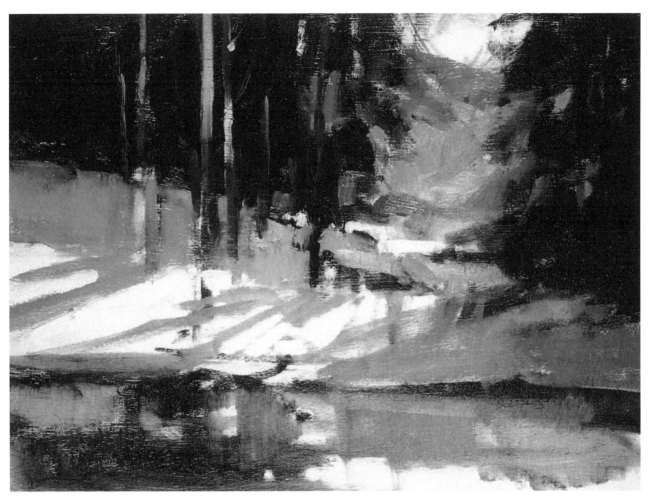

Step 3. Add some color

Viridian with raw sienna will look great in the background trees. Remember
to darken these greens with blues—ultramarine with viridian for rich dark
greens, ultramarine with sap green for really dark greens.

The shadowed snow is a mix of cobalt blue and white that forms a transi-
tional color passage between deep green and the white of the sunlit snow. Ceru-
lean at center adds an appealing color shift. The cerulean is a touch warmer,
tending to come forward, while the cobalt recedes. Violet along the edges
recedes even further. Notice how this draws your eye to the trees?

Warm gray in tree trunks comes forward, while violet-gray distant moun-
tains push the background way back. I use this violet mix quite often. It
has just enough red in it to complement the dark green. An atmospheric blue
passage—the very pale blue just below the mountain that might be fog, haze or
ice crystals in the air—will enhance the depth there, too.

Thickly brushed-on white highlights the sunlit snow at left foreground.
The right foreground is very much a subordinate area; that is, it's not in the
point of interest. Areas like these should be kept closely related in value, with-
out much detail, and with few, if any, hard edges. Remember: Contrast,
detail and edges tend to draw the eye.

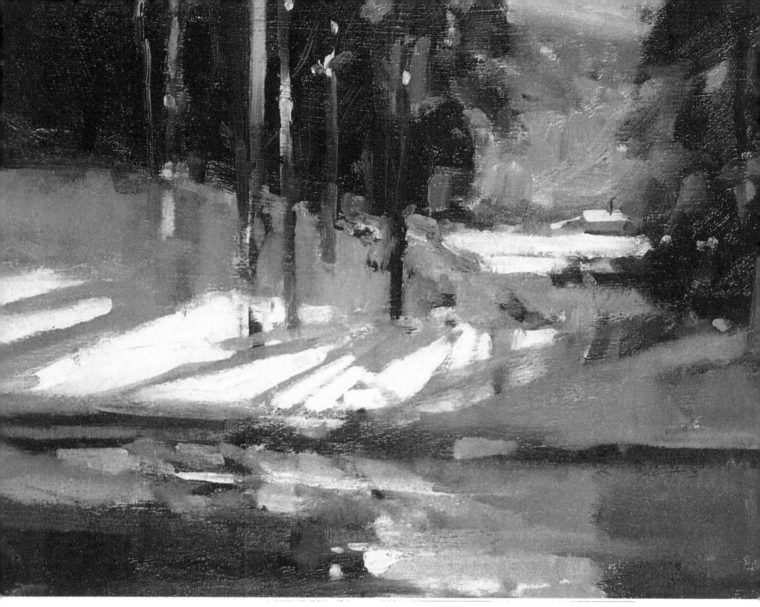

WINTERY LIGHT
oil on panel, 12″ × 16″

Step 4. Save the point of interest for last

I move to the foreground to finish the water. I make my reflections a degree or two darker. Not only are lower-key reflections characteristic of what you'd see in nature, they also help maintain focus in the point of interest.

Finally I deal with the point of interest itself, the distant field seen through the gap in the trees. Warm white, not as bright as the foreground snow, drawn across the gap establishes a snowy field. In the distance, I lay in the suggestion of a house that immediately becomes the focal point. Note how little detail is required in that house—roof form, chimney, wall with a dark bottom edge—yet how well it reads.

Finishing touches include spots of broken color. In this instance, pure cadmium orange, pure white, and dots of sky tone all add life and sparkle.

Compare my finished painting with the original source material and you may wonder how one inspired the other. Remember that the role of source material is merely to get you started. After that, you should change anything in the source that doesn't contribute to making the finished painting more powerful and effective.

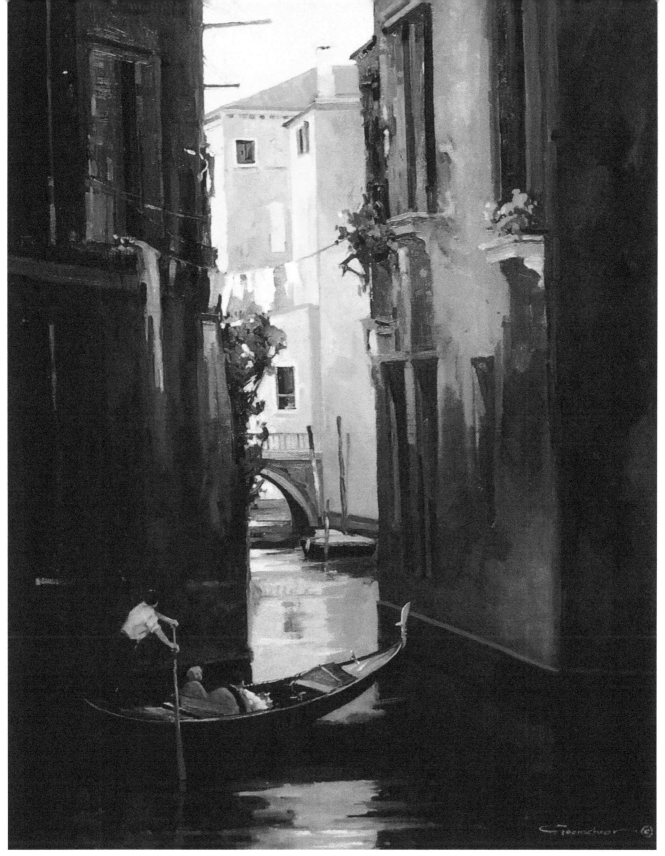

THE GONDOLIER
oil on canvas, 40″ × 30″

Where's the point of interest?

A variety of devices create the focal point in this Venetian scene. The viewer's attention, though drawn toward the distant sunlit region at center, is immediately diverted to the gondolier with his white shirt contrasting strongly against the dark shadowed background. Once past the figure, the curve of the gondola, the red of its seat repeated at upper right, and the arc of the sunlit clothesline, all serve to move the viewer's eye around the painting.

Paint-On Critique

In this painting, all of the interest is at left center. That's fine. Even so, we have to establish dominance within the center of interest. I'll emphasize the building on the right and play down the one at left.

ARTIST
Sue Hunter
Scottsdale, Arizona

BEFORE

Too busy; background trees should be big, simple shapes

Highlight could be brighter

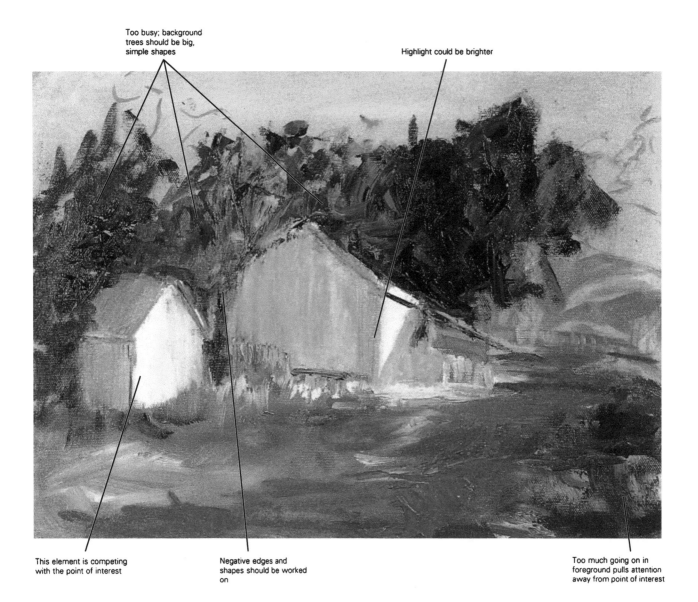

This element is competing with the point of interest

Negative edges and shapes should be worked on

Too much going on in foreground pulls attention away from point of interest

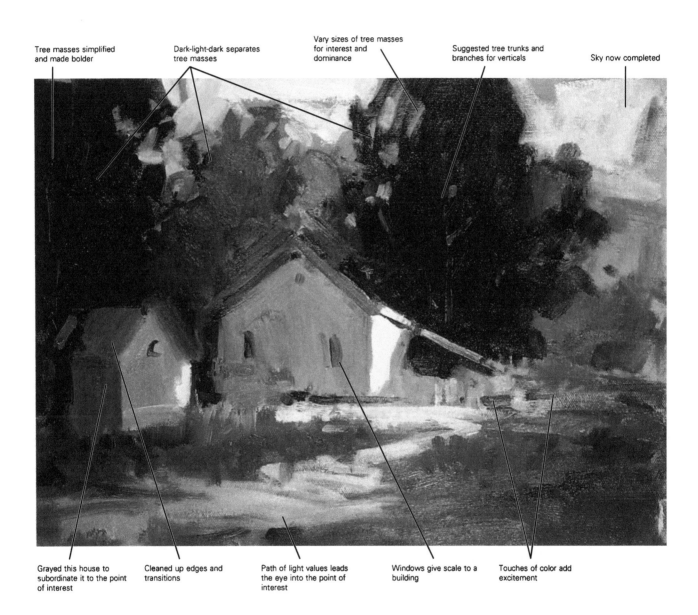

Tree masses simplified and made bolder

Dark-light-dark separates tree masses

Vary sizes of tree masses for interest and dominance

Suggested tree trunks and branches for verticals

Sky now completed

Grayed this house to subordinate it to the point of interest

Cleaned up edges and transitions

Path of light values leads the eye into the point of interest

Windows give scale to a building

Touches of color add excitement

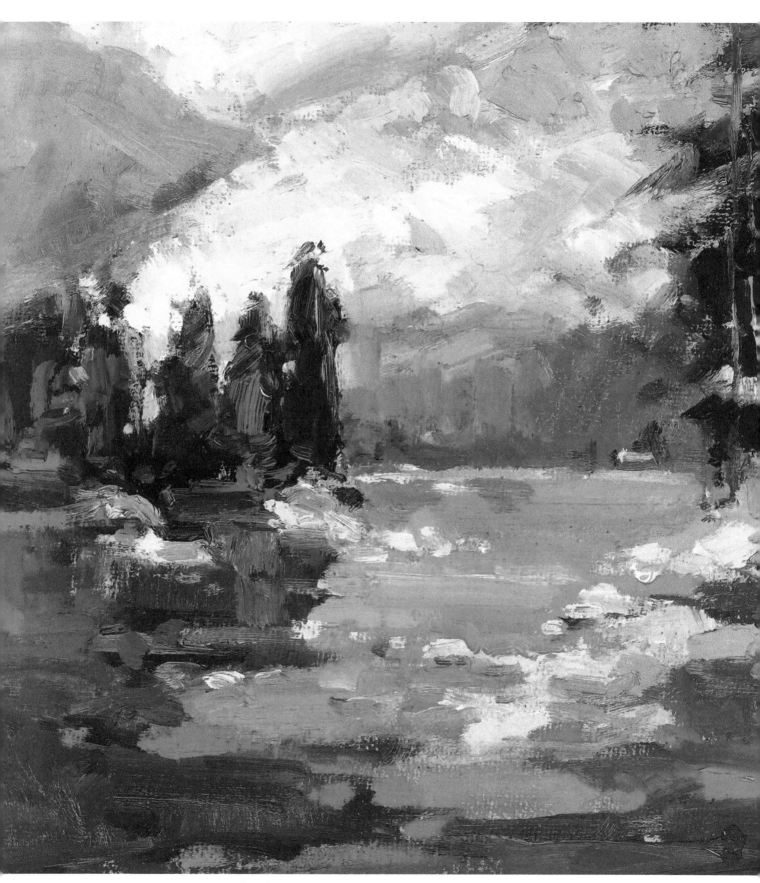

SIERRA POOL
oil on panel, 12″×16″

Practice, practice, practice
I did this little oil sketch on location in the Sierras of California. A good deal of outdoor painting experience underlies my ability to make this kind of simplified rendering of an extremely complex subject. But you can do it too. Begin painting outdoors, simplify what you see and think abstractly. Stick with it and you will *become a good landscape painter.*

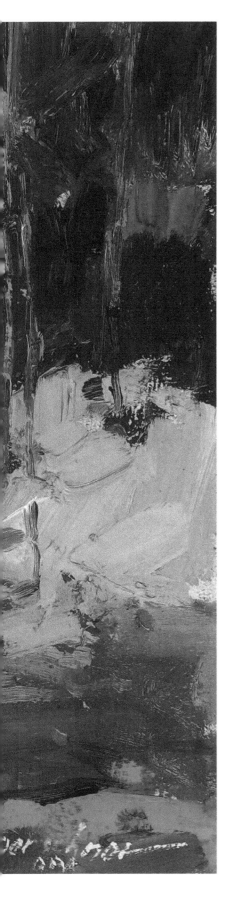

Painting Under the Sky

Before heading out on location, a quickie demonstration highlights some principles to keep in mind. Then we'll load up and hit the road to the tiny village of Harmony, which is really little more than a grouping of weathered buildings: antique store, pottery, some shops in the old creamery building, and a few scattered houses.

Keep It Simple . . .
Keep It Fresh!

Working alone, it would take me about twenty minutes to complete a subject like the one in this next demonstration. While speed is not the main thing, working quickly teaches you to get colors down right the first time and to make fewer mistakes.

Enough philosophy! Let's get to work!

Quite often, as you've already seen in these pages, I begin a painting without a line drawing because I can feel the form and the planes without having to put down the lines or the details. That's one value of experience.

When you go out on location, you'll often find scenes like this one: a grouping of little houses nestled under some trees. This scene was photographed somewhere near Mendocino. It's nothing special, but a lot can be done with it. The best part is the beautiful shape of the trees: a big dominant form with lots of movement. The fence posts in the foreground are nice, as is that wild rosebush.

Inspiration only!

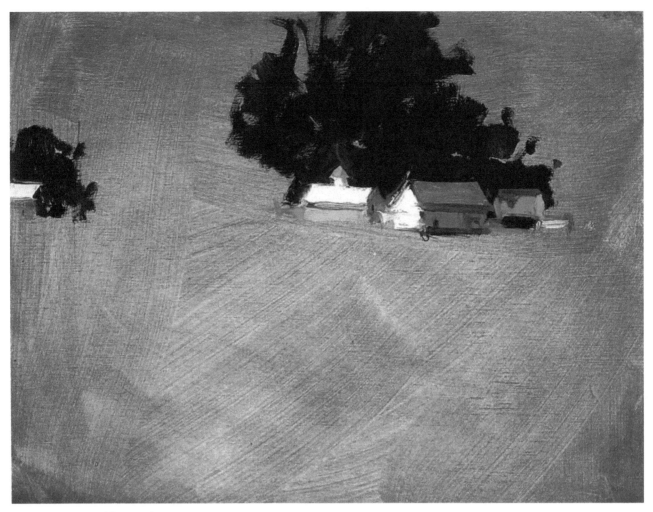

Step 1. Off and running . . .

I've already decided that my point of interest will be in the upper-right quadrant of the painting. I'll use a "steelyard" arrangement, beginning with the white roof at dead center, then adding the other roof on the right. I'm blocking in masses, not concerned with outlines or objects, but only with how well the values work against each other. Now I can come back with the dark tree mass.

With high-chroma blues, orange and white, I suggest objects around the two main buildings. There are always things around farm buildings—old tractors, machinery, hay bales—that can be suggested. They don't need to be defined. Bold strokes carrying lots of paint suggest forms and even objects the viewer can define in his mind. This is how to do bright, fresh paintings: simplicity of brushwork and bold color.

I place the secondary element at extreme left, again by blocking in the mass and then coming back against it to establish its edges with the dark of the trees.

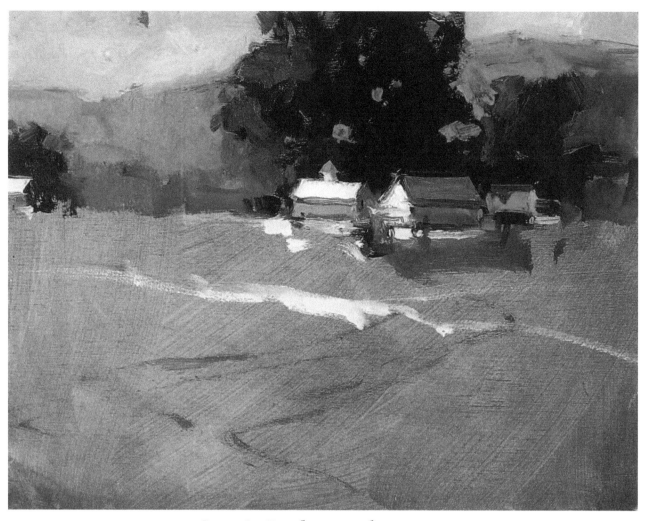

Step 2. Background next

There are no mountains in the photograph, but I'll add some distant hills, using them as an opportunity to poke a few holes through the trees. I quickly get a sky tone down as well, just to establish the value.

Yellow-green into the left side of the tree masses establishes both lighting and form. Little shapes around the focal point frame it and strengthen interest. Then a swath of Naples yellow below the house and just a few strokes to establish the foreground plane.

Variety Creates Interest

Fence posts lined up like soldiers . . . Boring!

Static shapes and monotonous repetition don't lead the eye anywhere.

Now this is an interesting fence!

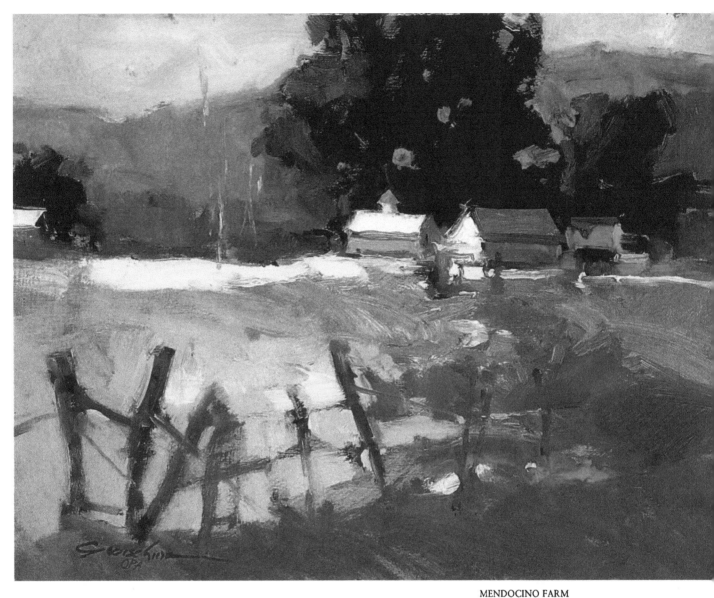

MENDOCINO FARM
oil on board, 11" × 14"

Step 3. Foreground last

Not a lot needs to be done with the foreground. Do it fast and loose, *then leave it alone*! Let's start with those fence posts. I want to make them interesting . . . "dancing" the viewer into the painting! Take a look at my sketches on the previous page.

Now I'll work around the shapes of the fence, softening its hard edges. Light green toward the meadow's distant edge . . . warmer green in the foreground . . . a suggestion of flowers. The middle-ground light swath continues to both left and right. I positioned my no. 4 round brush almost parallel to the surface, rolling it in my fingers as I drew it across the panel to leave an actual ridge of clean color. No sharp edges or detail in the foreground.

Does it need anything else? I think not.

Paint-On Critique

T here is a strong point of interest but very little else to look at in this piece. What's needed here is a secondary focal point and other interesting elements to lead the viewer's eye around the painting.

ARTIST
Angela Headley

BEFORE

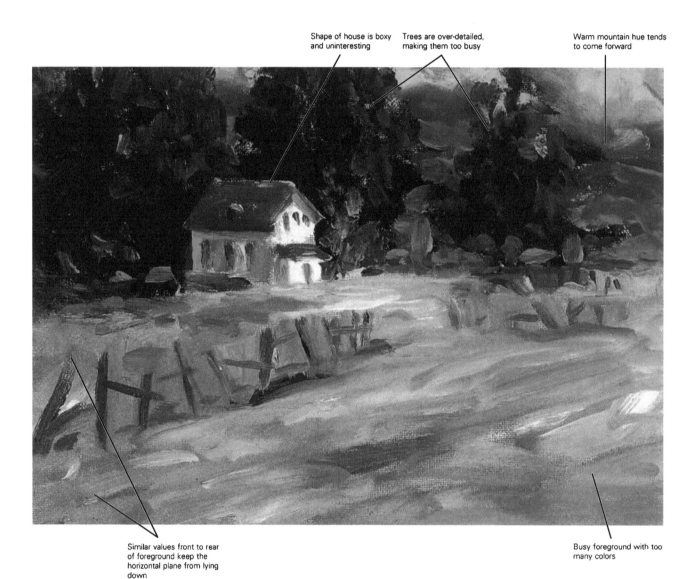

Shape of house is boxy and uninteresting

Trees are over-detailed, making them too busy

Warm mountain hue tends to come forward

Similar values front to rear of foreground keep the horizontal plane from lying down

Busy foreground with too many colors

AFTER

Adding a shed elongates shape and adds interest

Windows, not detail, give proportion to a house

Tree masses simplified

Cooler mountain hue recedes

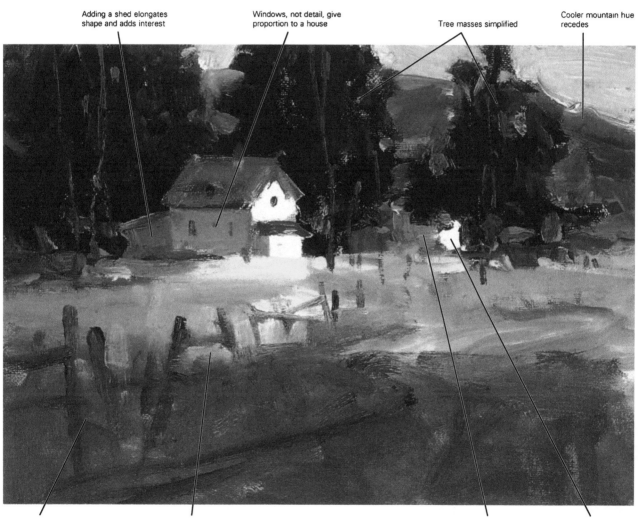

Fence repainted as a diminishing, pointing shape to lead the eye into the painting

After the fence was repainted, the negative areas were done in yellow-green, softening and losing edges to avoid focusing attention on ·fence and foreground

Adding a shadowed side makes the white dot into a structure

Spot of white creates a secondary point of interest

Welcome to the Great Outdoors

We're about to go outside to paint. There are a lot of things I could say in advance, but I'll start by recommending that you work smaller—8″ × 10″ to 12″ × 16″—rather than larger. For one thing, there's not as large an investment, either time-wise or emotionally. If something isn't working, you can easily wipe it off and start over. It's a lot simpler to tackle a size you can complete in a couple of hours or less, especially when you're dealing with changing conditions.

The early morning sun is warm, the air cool and filled with birdsong, as we set up beneath a cloudless sky. I squirt fresh pigments on my palette and check around for the likeliest subject. When you arrive on location, take a walk around and look at your scene from various angles. I'd hate to get most of the way through a painting only to discover the ideal viewpoint was a few yards away!

Keep full sunlight off your canvas. It's the strongest light there is, and it will throw off your sense of value. When you get back to the studio, you'll find that all your colors will seem too dark! I use my Russian artist's umbrella which has a long, telescoping pole I can poke into the ground. It's white on top to reflect light, and lined with opaque fabric to prevent light from filtering through and coloring my canvas. An ordinary umbrella with colored panels will throw your color perception way off. If you must use one, spray paint the inside black!

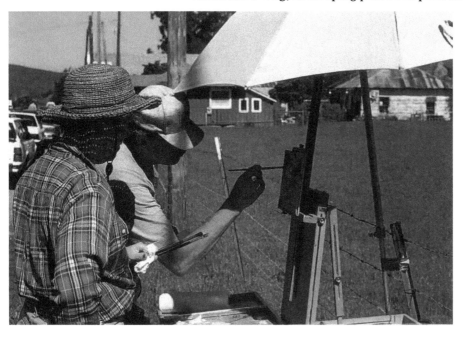

I prefer to paint on panels when working outdoors. Light coming through a stretched canvas is very distracting.

Always think design first

What if I told you to take a 9″ × 12″ and make a nice design on it, without even mentioning subject matter? Right off, you'd have to ask yourself, "What kind of a design can I make?" You'd have to think *shapes*. Your subject matter can then be used as a vehicle to make that design.

The house in this scene, of course, will be my focal point. I'll eliminate the rusty roof but keep that contraption on the right—it's a nice linear design element. I'll put trees in the background and leave out most of the junk, using just a few dots of color for that.

The middle ground tells you what the background should be; that is, the background can make or break your painting, so design it to make the point of interest work.

Step 1. Sketching

I'll begin sketching with burnt sienna and manganese violet, using my no. 4 filbert. Do as much sketching as you wish. I try to do very little, because I want to get the feeling of paint on canvas as quickly as possible.

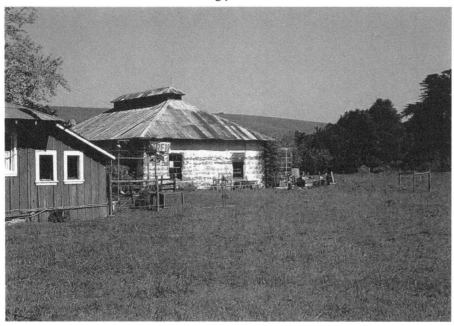

The subject for this morning

WHAT TO PUT IN, WHAT TO LEAVE OUT

Before putting an element into a composition, always ask yourself, "Will this add to, or take away from, the point of interest?" If the answer is "take away," leave it out!

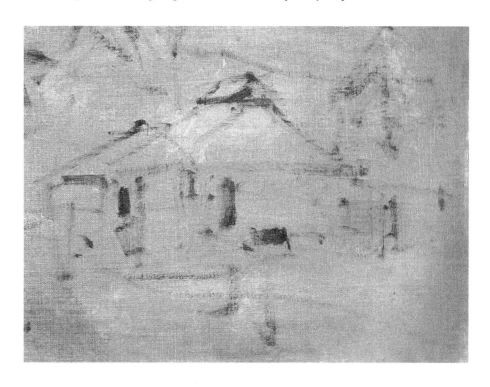

61

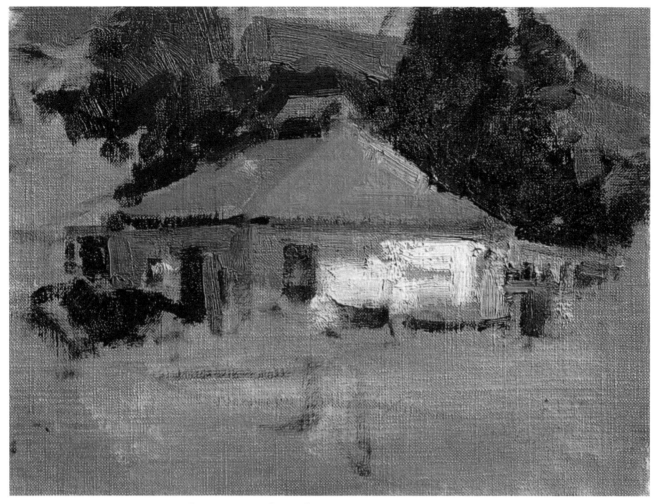

Step 2. Laying in planes and values

The left side of my building is in shadow. The facing side, my point of interest, is brightly highlighted by white mixed with cadmium yellow. Now watch as I change those shadows, creating more interesting shapes by tinting them with complementary violet-grays.

Remember, *take any liberties you want* if they enhance your design. Paul Cezanne did. All the great painters did. That cuts you loose! *Push your color!* Don't be a slave to what's there. I'm keeping this loose and bright.

Now for the right side tree mass. The green is sap with raw sienna, shadowed with ultramarine blue and magenta. Note how I pull negative shapes through the framework on the right.

Pay attention to value. Light's coming in from the right, so I'll keep the right sides of the trees light and shadow the left side.

Now I put in the left tree form, darker because it's farther from the light. I extend my tree forms up off the panel and edge them sharply around the roof line. Good strong dominant and subordinate shapes there, each having dominance and subordinance within it.

Next I scrub in my distant hillside. My color is a mix of viridian, white, and a little manganese violet. See how blue it looks?

DON'T BE AFRAID OF THE DARK

Don't be afraid of getting a value too dark right off the bat. You can always go back and lighten it. On the other hand, while the paint is still wet, it's nearly impossible to lay in dark over light.

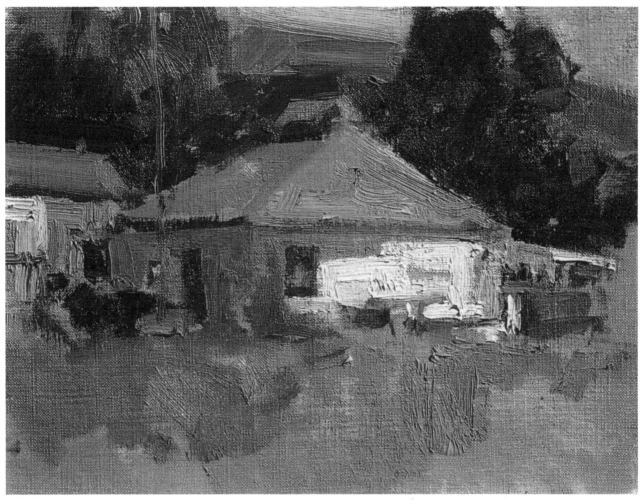

Step 3. Working around the point of interest

Now I can start throwing some bright color around my point of interest. I know you can't see much in the subject, but color is what's needed.

I'm adding broken color along the base of the building. See how it sparks up the point of interest? These undefined shapes could be almost anything. It really doesn't matter, as long as the composition works. In a painterly painting, much of the definition is left to the viewer. That's how it should be. Do only as much as necessary to make it work. Sky value and distant hillside help set the key for this painting—not as bright as the point of interest highlight, though. I don't want to take away from that!

I lay in some foreground—viridian-based green on the left, away from the light.

A NAGGING DESIGN PROBLEM SOLVED

I'm gradually becoming aware that my composition needs another shape to the left of the building to bring the group mass together. I add a barn, laying in a warm gray roof, then a weathered tan facade. Ultramarine and viridian extend the tree mass to create the top edge. A heavy highlight on the facade echoes the light on the house. A flash of red enlivens the roof.

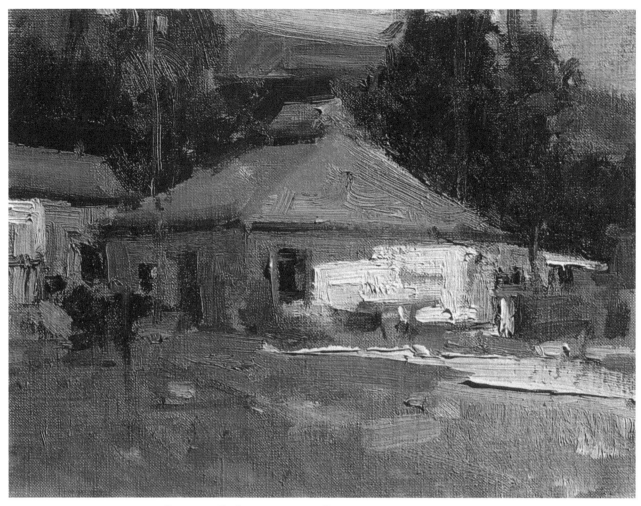

Step 4. Tree trunks and foreground

Tree trunks, with a few branches, add vertical emphasis. Finally, I'll scrub in
the foreground loosely, with no detail, and leave it alone. Then violet-gray
in the shadowed left side, a mix of yellows at right foreground, a slash of
nearly pure cadmium yellow light, and a touch of manganese violet just below
it for emphasis.

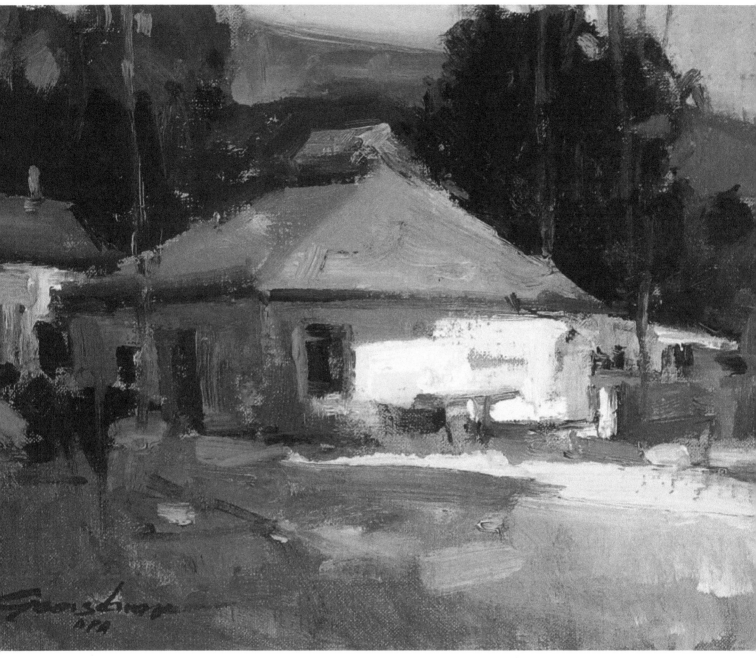

HOUSE AT HARMONY
oil on panel, 9″ × 12″

Step 5. Finishing touches of color

The painting's not quite finished. I add more broken color in and around the point of interest and open up shadows with cobalt blue, for sparkle. A few more touches of color and my signature. Done.

Paint-On Critique

The main problems here concern the muddy sky, the shadowed side of the house, and the way the shed on the dark building comes in at almost the exact angle that the other roof enters from the right. The two roofs conflict with each other, neither one being dominant.

ARTIST
Marijane Hebert

BEFORE

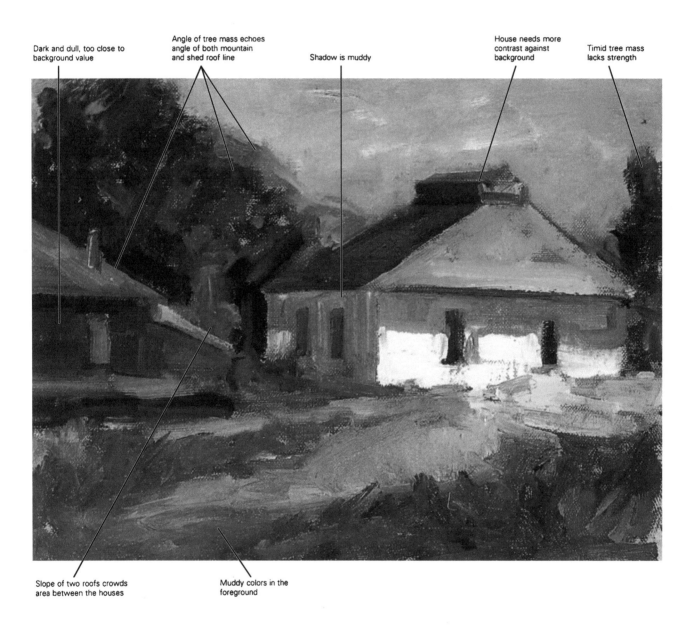

Dark and dull, too close to background value

Angle of tree mass echoes angle of both mountain and shed roof line

Shadow is muddy

House needs more contrast against background

Timid tree mass lacks strength

Slope of two roofs crowds area between the houses

Muddy colors in the foreground

AFTER

Darkened and reshaped tree mass; note dominant form on left, subordinate on right

Bright, clean cobalt blue and white sky, darker at top, with suggestion of clouds

Hints of brighter colors in shadows

Sunlit roof brightened, with some darks showing through for contrast

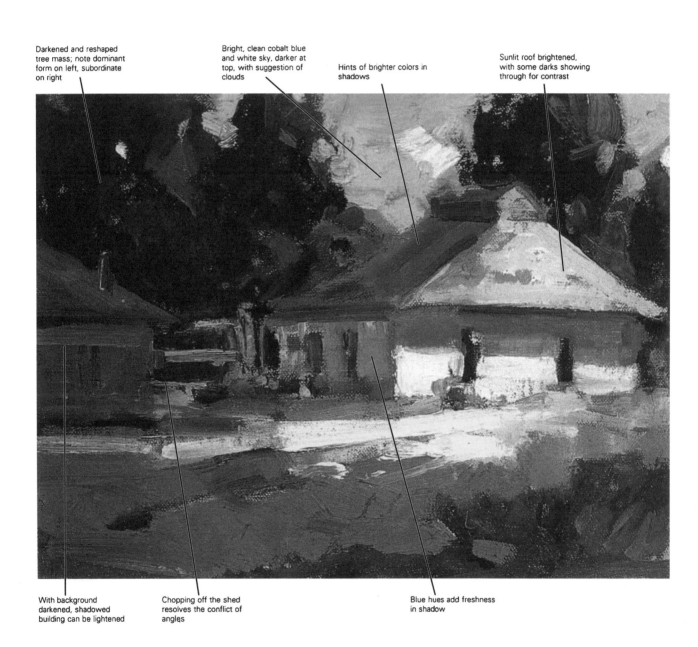

With background darkened, shadowed building can be lightened

Chopping off the shed resolves the conflict of angles

Blue hues add freshness in shadow

Ignore What You See . . . Paint What Works!

HARMONY, TAKE TWO

I t's afternoon at our roadside studio, and we're looking at the same scene we painted this morning. But see how the light has changed. The wall facing us is now in shadow, while its left side is in bright sunlight. That new dominance of shadow and subordinance of light—can it spark an exciting painting? Certainly it can spark a different interpretation.

I'll use this demonstration to show how little is really needed from subject matter. Watch as I make this rather uninspiring scene into an exciting, colorful painting.

Step 1. Sketching the composition

This time, I'll tone an 8" × 16" panel, and set up a "steelyard" composition: the white house close to center on the right, the red one coming in from the left. You can see in my sketch how I'm closing the distance separating the white house and the red one by moving the barn into the space between them and making it higher, using a tree form to break up the linear shapes. I'm also changing the line of the hillside so it rises behind my focal point of interest, supporting instead of taking away from it.

Finally, I'll sketch some contour lines to suggest the way the foreground slopes. Later, when putting in my brushstrokes and shadows, I'll know what to do with them.

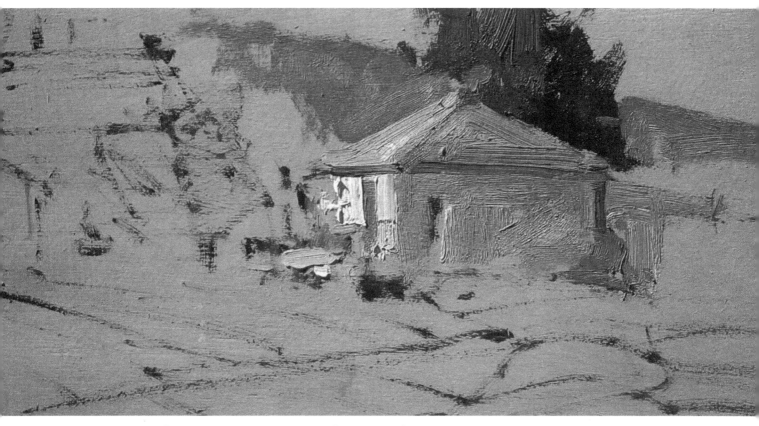

Step 2. Pushing paint . . . pushing color

This time I'll use some of my mud, the scrapings from this morning's palette warmed with a little yellow ochre and violet, to lay into the shaded face of the white house. A couple white strokes for the sunlit side; are the values working together? Yes!

Now, here's a prime example of ignoring what's there and putting in what you know is right: A painterly painter won't even try to represent that roof the way it is. I'll treat it as simple opaque surfaces.

Just three brushstrokes describe the left, sunlit side. Three more for the near face. These are the kind of straight, bold brushstrokes you should be learning to do: stiff armed and from the shoulder, not the wrist.

Now I can start working out from the point of interest. I'll move the dark tree mass right, to outline and contrast with the roof line. The distant hill is brushed in, lighter and grayer but not as light in value as the roof.

Here's a hint of color to come: Pure cadmium red and cadmium yellow bring the proceedings to life!

Step 3. A mishmash of forms . . .
a festival of color

Look at all the nice stuff beginning to happen to the left of the building!
A stroke of color can sometimes spark excitement in a painting that has
become dull. Try it!

I want a lot of hot color happening all in that one area. I'll create contrast
with dark greens and dark violets (a mixture of magenta and ultramarine
blue) above, playing that against the bright white highlight. See what I mean
about the middle ground painting the background? Alizarin crimson is the
basis of my rich, warm darks here. A mishmash of forms, but look at how
well those shapes work together.

The building group at far left is now laid in with a strongly analogous
range of middle- to dark-value red-violets. Very appropriate for a secondary
point of interest; present, but not intended to catch the eye. I simplify the
background above it by carrying the tree mass, dark with ultramarine in
the green, off the panel.

Liking the contrast between high-chroma colors and white, I pick up my
rigger brush and add white linear beanpoles (or whatever they are) for still
more contrast. Dark poles against the light right side. Spots of high-chroma
broken color appear around the point of interest.

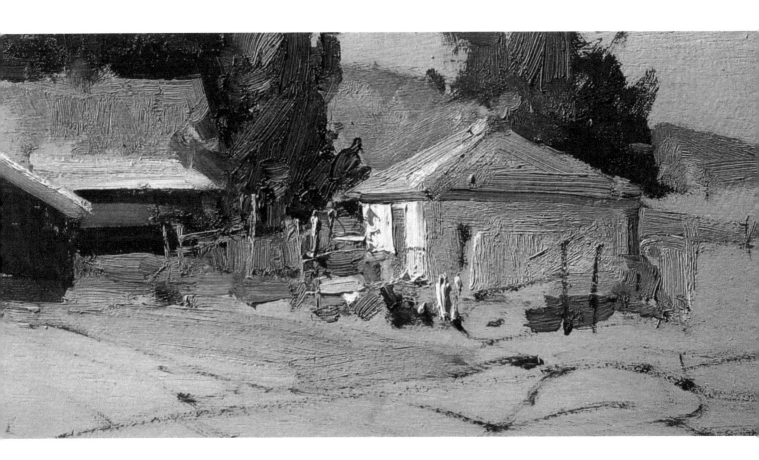

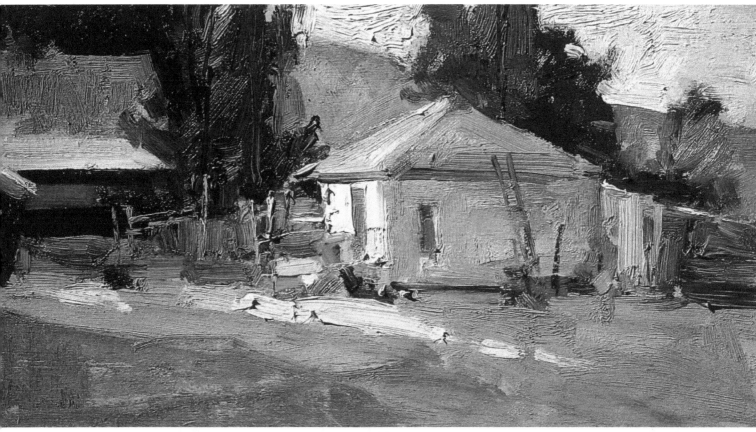

Step 4. Push it to the finishing stroke!

Sometimes the most fun comes from seeing how far you can push a painting. I'm pushing hard on this one.

How about getting away from blue sky? Let's try a *complementary* sky! A touch of cadmium orange in white, and I scrub that in. Then I come back with an equally high-key overpainting of cobalt blue and white. Look how that sets up the lighting in the scene!

To the right of the white house, I darken the middle ground with manganese violet and add strokes of marbleized green and orange. A few flashes of light reflect from the shed roof.

I'll stand that ladder against the house to break up the mass and suggest more of the junk around it with dots of broken color.

My foreground is simple and dark to move the eye right up into the middle ground. Too light and it would lead out of the picture; too detailed and the eye would focus on it.

I mix pure white and cadmium yellow, using a palette knife to keep it perfectly clean. Then, with a clean brush I dash that streak of light across the foreground.

Finished!

HARMONY AFTERNOON
oil on board, 8″ × 16″

EDUCATE YOUR AUDIENCE

There's a fine old saying: "Don't paint down to your audience. Make them come up to you." Doing mediocre paintings so the public will easily understand what they're looking at—that's "painting down." Educate the public with your work. Bring them *up* to your level.

Paint-On Critique

The main problem here is lack of dominance. All four houses are of nearly the same importance and equally spaced. One must dominate. Notice how, after I have reworked it, the right half of the painting dominates the left as the point of interest becomes strong.

ARTIST
Florence Weismann

BEFORE

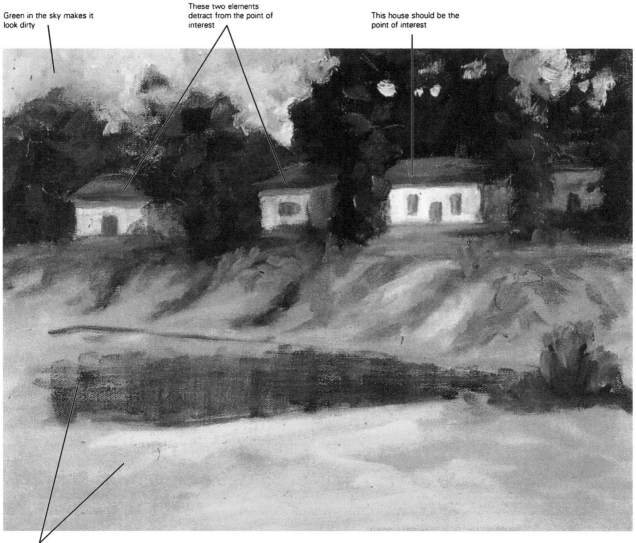

Green in the sky makes it look dirty

These two elements detract from the point of interest

This house should be the point of interest

Both parts of foreground are the same size

AFTER

This is a transitional hue,
easing passage from
shadow to highlight

Dominant tree mass here
supports the point of
interest

Simplify to keep interest
focused above

Shadowed violet and soft
edges keep eye on the
painting

Suggestion of very
subdued building as
secondary point of interest

Size of pond increased to
dominate adjacent areas

Shape of pond changed to
give direction

Shadowed yellow should
dominate highlight

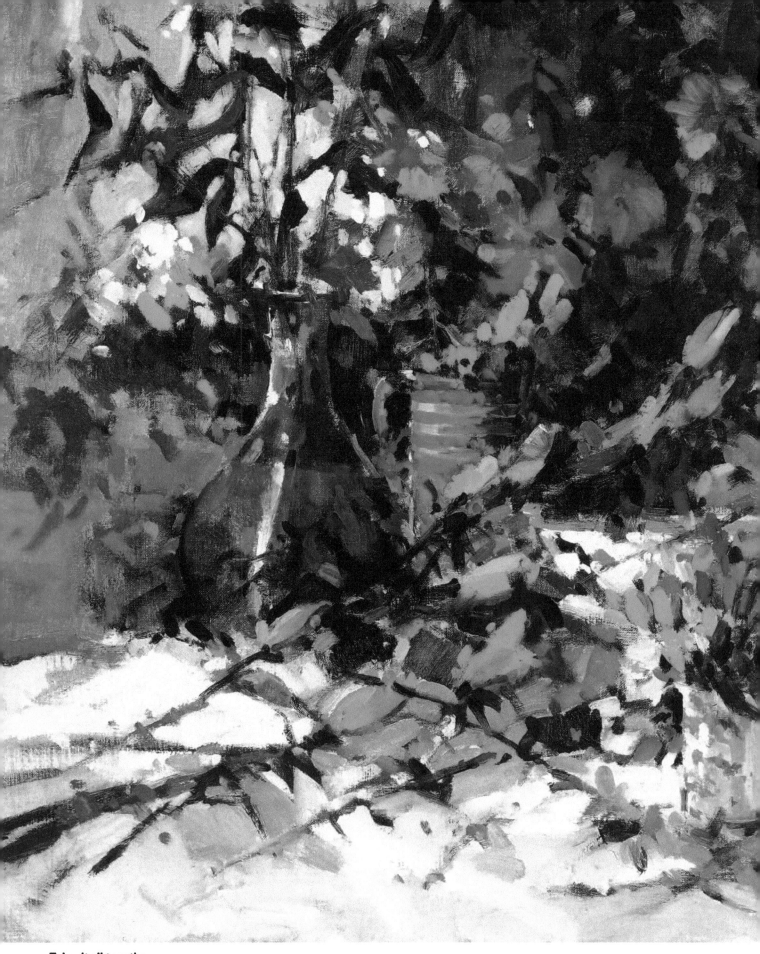

Tying it all together
The glass jug is my point of interest, so elements around it are sharpest and most contrasting.

Foundations for Success

To my way of thinking, subject matter is irrelevant. Whether you're facing a landscape, a seascape, a floral, a still life or even a figure, your approach should be about the same. In other words, every painting involves solving the same problems and can be successfully completed by going through the same steps.

I'll prove that today by taking three very different paintings—a floral, a landscape and a harbor scene—through the same five steps. Then I'll do a second floral and introduce you to "Goerschner flowers"—the prettiest flowers of all!

FLORAL WITH ROSEBUDS
oil on panel, 16″×20″

Five Keys to Successful Paintings

1. Plan

Every painting should begin with at least an elementary plan. Take the time to make a few penciled value sketches, or line the composition out in paint on your canvas. There's a better chance of arriving where you want to be if you know where you're going.

This picture of a Colorado farm is a favorite of mine. This will be a "steelyard" composition, with the heavier mass (the house at right, which will also be the point of interest) closer to center and the smaller mass (the structure at left) farther out.

Here's a great snapshot of Peggy's Cove, Nova Scotia—possibly the most frequently painted and photographed fishing village in the world. I'll plan for a high horizon to show lots of reflections. My focal point will be at upper left center, based on a "golden section" compositional scheme. I'll bring light in from right rear, putting the lobster shed into shadow, catching brilliant highlights at left. That also allows me to make that shed the dominant mass in the painting.

I'll take a little from each of these two photographs in planning this floral, using a "golden section" composition with point of interest at upper right center. I'll simplify a lot. Remember, florals are nothing more than color and form. What the actual flowers are doesn't really matter. Maybe they're "Goerschner flowers!"

2. Block in the masses

I usually start by toning my board to a medium neutral value. Brush it on and wipe it off. With that in place, you can sketch in your composition as I've done with my first two subjects, or go right ahead and block in the dominant shapes as with the floral. What's important is to decide on the major shapes so you can get them to work together.

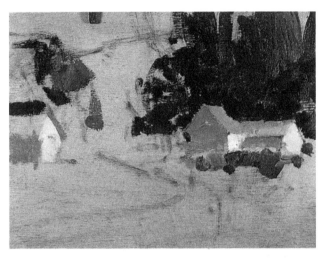

I've taken the time to get my drawing right before working on the forms. I've built up my major mass at right, even changing the slope of the mountain to support it. My lay-in usually begins with the focal point, because everything relates to it. That's why you see those brilliant whites and darkest darks already down.

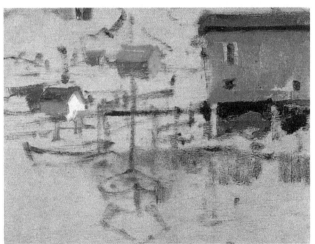

This is a challenging subject, with a lot of detail for a small painting, so I've done a careful drawing before laying down my color. Note how I've blocked in my dominant mass—the shack at right—and spotted in the whitest white and highest-chroma color at left. It's important, at this stage, to be thinking in terms of shapes, not objects.

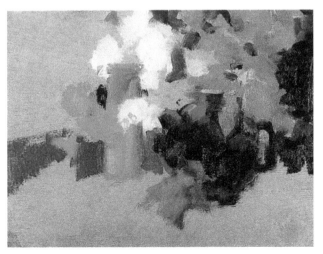

I'll begin my floral by blocking in the dominant mass—the dark jug—then lay in a progression of pinks from top right to bottom center to establish the movement, and finally add the white floral mass for balance. Note how I vary hues and chromas as I work out patterns. What's important at this stage is just painting the shapes: Tune out what they are supposed to represent.

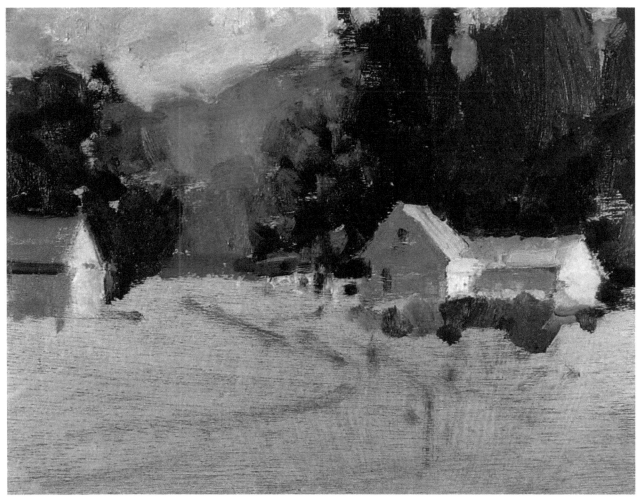

3. Develop the shapes

My paintings are still abstract compositions at this stage. Once they're blocked in, I can begin working within the shapes, developing them by adding more color contrasts, texture and detail. Note that I'm still thinking about two-dimensional shapes, not three-dimensional objects.

As I complete my block-in, I'm also paying attention to what's within the shapes, breaking up the dark tree mass at right, for instance, into lighter and darker values. The foreground will become a playground for closely related values of blues, violets and reds that are not defined at all, since too much detail would take away from the point of interest.

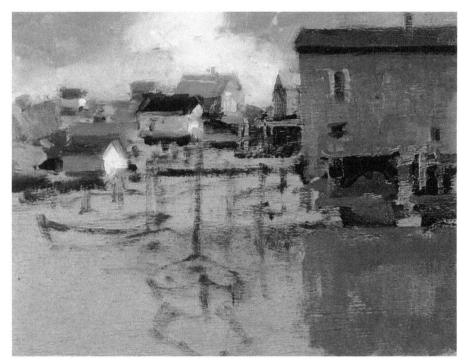

*Development of the two-dimensional shapes contin-
ues. Note how the sky has become more interest-
ing. With a large sky, as here, I usually want to put
more design into it—like these puffy clouds that
will set off the adjacent elements. Remember, in a
seascape or a snow scene, keep the sky a medium
value to avoid taking away from the point of inter-
est. Notice the dark, broken color I'm adding in
shadows, windows and chimneys.*

*Working on the shapes, I define
the background more, making it
cooler to push it back, and begin
to subordinate some of the white
blossoms with warm grays, while
bringing out highlights like the
white that streaks the cloth at
lower left. Notice, in the follow-
ing step, how much more devel-
oped the shapes have become.*

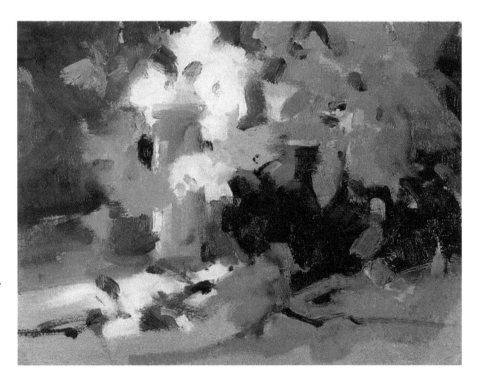

4. Relate the shapes to each other

Now my paintings begin to take on their three-dimensional character. In relating the shapes, I make sure subordinates are close in value to each other and have softer edges. At the same time, point-of-interest areas will develop sharper edges; brighter, warmer, higher-chroma colors; and stronger value contrasts. *That's the essence of successful paintings right there!*

Here I'm using cooler hues and lighter values to make the background recede and bringing up the foreground with darker ones, keeping the emphasis on the high-key center of interest. The foreground should walk you into the painting. The curved mass here will help with that. The house begins to show windows, shadows, chimney, etc., that help to give it scale.

I ad-lib light pilings against dark reflections on the pier, emphasizing the point of interest with high-chroma red against a dark blue-green foreground, blending that into the lighter values, adjusting the background, and picking up reflections of distant houses in the water. I'm thinking in three dimensions now, as overlapping forms and atmospheric perspective create depth.

I'm still defining the background. I've highlighted the vase at right and modeled some of the white flowers to give them a three-dimensional form. Broken color on the cloth is kept suggestive . . . not definitive. Individual flower masses are brightened to bring them forward, while others are pushed back. Using a large brush keeps me from getting too detailed, helping me keep this painting fresh.

5. Add accents

At this stage, I can stand back, take a long look at the painting, and decide what, if anything, is needed to complete it. I may soften, or even lose completely, some of the edges outside the focal point, or adjust value and intensity as I see how elements relate to each other. I'll probably add little staccato accents that lead your eye through the composition. These accents might be reflections, highlights or just high-chroma color, and are not necessarily identifiable as objects in the scene.

COLORADO CASITA
oil on panel, 9″ × 12″

Just a few touches bring this painting to completion. I soften edges in subordinate areas, highlight the horizontal streak across the middle ground, add light tree trunks against the dark greens for a three-dimensional touch, and finally add just a few spots of broken color for sparkle and excitement.

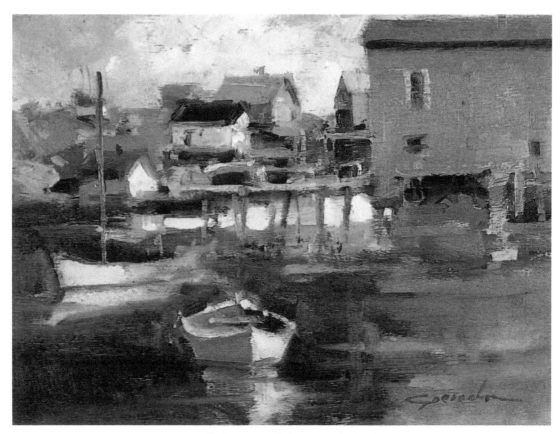

PEGGY'S COVE
oil on panel, 9″ × 12″

I'll shoot some light across the background water from the right. Then I'll detail the foreground boats, adding mast and boom to the sailboat. Note how that mast is dark against the sky and light against the darker masses. I'll blend some of the green water into the reflection of the big shed and soften the reflections of the boats. Broken color for sparkle, and the piece is finished.

FRESHLY CUT
oil on panel, 9″ × 12″

Still adjusting values, sharpening edges in the center of interest, and adding dots of broken color. I cleaned out some of the whites and added a few touches of magenta. Some calligraphy for branches and stems opens up the opportunity for a little negative-space painting between them. Many artists use a palette knife for their very brightest highlights at this finishing stage, since it leaves a smooth, reflective paint surface.

Push Color to the Limit

I'm probably better known for my approach to handling color than for any other aspect of my work. Let me show you how I "push" color with this little floral study.

This demonstration is a little more detailed than some of my others. The best way to follow it might well be with your own panel, your own paints, brush in hand, duplicating my steps as we go.

Simply remember to plan

Planning is merely answering the question: *What do I want to say with this painting?* For this subject, I want to say "flowers" and "color" as loosely as I can, with a minimum of brushstrokes. Let's keep that objective in mind as we paint.

Step 1. Establishing the dominant mass

I begin by laying down some violet-gray and spreading it around with a solvent-moistened bit of paper toweling. This tone will set me in the right direction.

My single-oil-primed, panel-mounted linen canvas absorbs the solvent, drying in about five minutes. Gesso primer takes much longer— often as long as five or six hours.

With a mixture of ultramarine blue and black, I lay down the dark, flat shape. I use a middle-value yellow for the secondary shape, adding cadmium orange to cadmium yellow medium, with a little orange "kicker" to the left. Finally, breaking up the black shape, I pull a little orange into the rim and blend a bit of yellow into the left side, recognizing that dark elements draw color from the rest of the composition. Notice how this establishes reflected light in the glossy black vase. This entire element—vase and flower shapes—will be the dominant mass in this painting.

Step 2. Continue the block-in

I'm still going for the basic shapes. I'll add some dark orange against the vase at left.

Looking for a subordinate mass, I'll lay in a large green leaf shape to the right of the vase using a mix of greens with ultramarine blue. Having done that, I can see the need for a further subordinate shape to its right. A second leaf. Later, I'll come back and break these up. Yellow ochre and Naples yellow are added to my green for leaf masses at left. A spray of white flower masses creates movement across the top, down the left, and back toward the center. I also begin to set up the fold of tablecloth beneath the vase, coming back with black to shape that edge pleasingly.

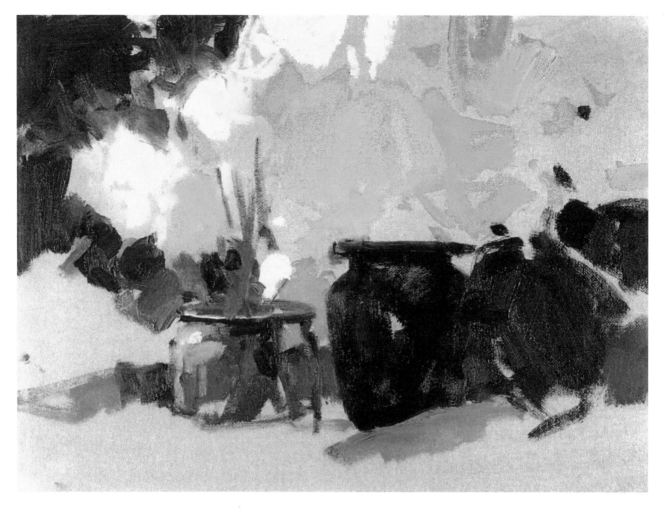

Step 3. Values and contrasts

With light entering this composition from the left, look how strong I make this background on that side. Notice how the contrast pops!

Time to put the glass jug in. I'll make it a little bit squatter, in contrast to the taller black vase, and use my greens to suggest the glass reflecting foliage inside and out.

This is a good time to lay in a light violet horizontal that ties the major dark masses together and suggests the vertical plane of the background. Violet is a fun color to work with, but you have to keep it clean. Note how I vary the color as it moves through the painting.

To do a highlight like the one I've added around the rim of the glass jar, first paint the white, using a rigger or the narrow edge of a flat. Then come back against it from the top, using green to smooth the edge. Last, brush in on it from below (I've used a very dark green-black) until you have a fine, even hairline.

Still working on the glass jar, I use some light green for reflections and just a dot of white for a highlight. I brush in a little calligraphy to suggest stems as I begin to pull the image out of the abstract.

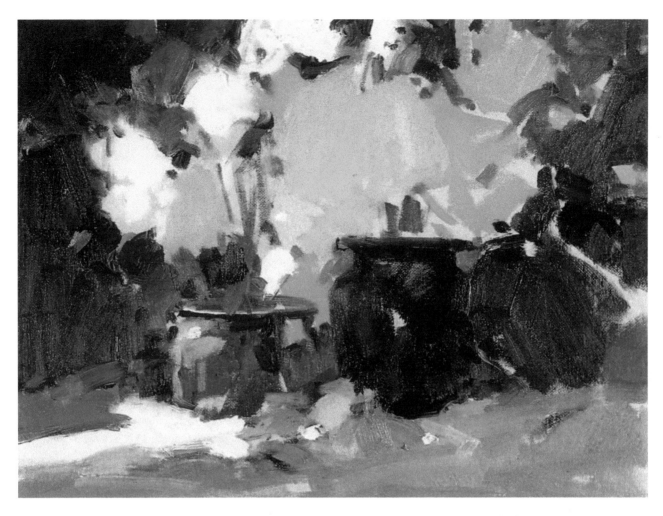

Step 4. Working with shapes and forms

Continuing from the background at top left, I work my way toward the right, jiggling violet hues into the spaces between my petal and leaf forms, varying analogously from blue-violet through red-violet. Ultramarine blue and alizarin crimson give me the strongest violet on my palette.

As the composition develops, I feel the need to bring yellows into the bottom of the painting: What could be better than a fallen blossom? I wipe out some of the blue cloth and brush in a dark yellow, partly shadowed, wilted blossom that overlaps both vase and jar, tying them together. Loose petals are added, with a dot of alizarin crimson at the center and a higher-chroma yellow petal for a highlight. The foreground is filling up with interesting shapes. I can justify their identities later. Or not!

Back to the foreground: a streak of light and touches of white around the blossom. Broken color adds a staccato rhythm to the composition.

Now I'll block in the foreground, using my violet-gray, to keep it really subordinate. Notice how I brush into the petals and stems without much apparent regard for them. After all, they're only brushstrokes!

GIVE IT TIME

Learning to paint is a lot like learning to drive. In the beginning you're thinking about everything: braking, shifting, steering. Eventually, these become automatic, and you can do lots of other things while driving: spot hazards, plan a route, merge. Painting's like that. When the "craft" part becomes automatic, the creative side takes over.

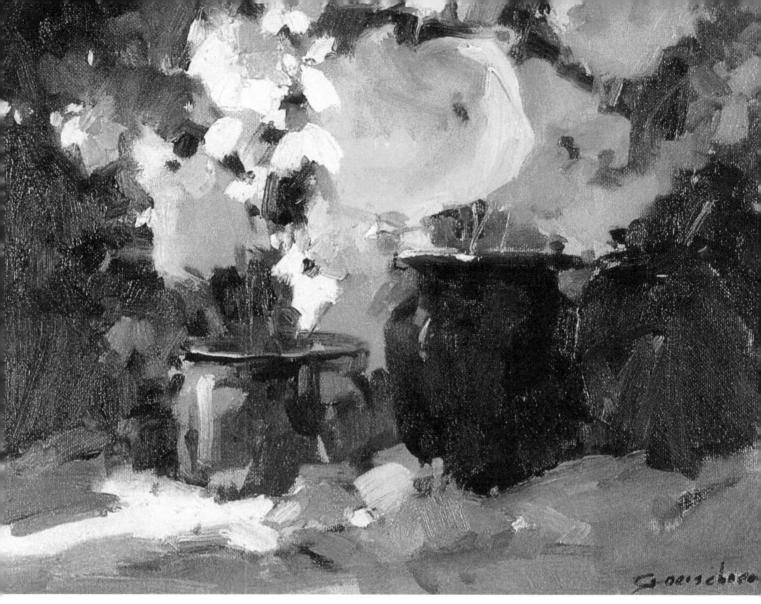

Step 5. Softening edges, beginning to focus

YELLOW AND ORANGE STILL LIFE
oil, 9″ × 12″

Focusing on the central blossom, I come up in key now, using bright cadmium yellow with a little white around its perimeter, repeating that color to create hot spots on other yellow blossoms. I darken the core of the main blossom with cadmium orange, bring in a shadow value along its top, and darken the adjacent background to increase contrast. Spots of pink suggest flower shapes at right and left, sparking up the background and lending a mosaic-like quality. I work on the white shapes, simplifying them, pushing parts back using my neutral gray with just a touch of yellow in it (remember—shadows draw color from adjacent areas!), while pulling others forward with pure white.

Playing with the flower masses on the left, developing the vase mass a bit more, adding broken dots of red and pink, brightening orange values, we move to the final stage. Some calligraphic lines for stems help tie the composition together and give a little relief between line and form.

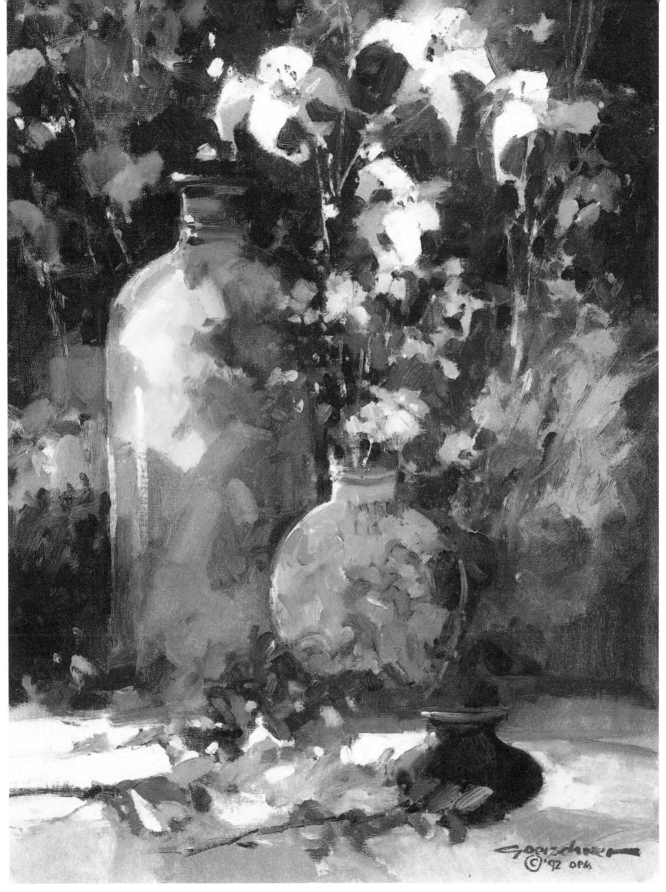

AMBER JUG
oil on panel, 18″×24″

Challenge in simplicity
The major forms here are the amber jug (a favorite prop that you'll find in a number of my paintings), the white lilies, and the red flowers at left. The small blue vase is there for depth and color contrast, helping lead your eye to the major forms. Most still lifes are a challenge in simplicity. You really must simplify patterns, thinking more abstractly in terms of design. Florals are great practice!

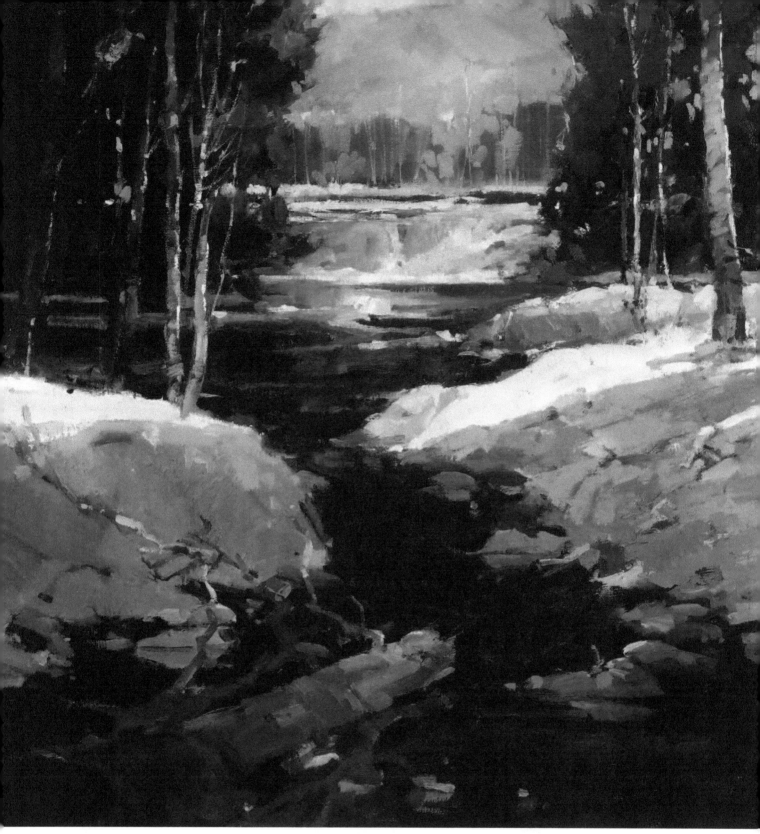

FIRST LIGHT, SIERRAS
oil on canvas, 36″×48″
Collection of Marijane and Mel
Hebert

Major painting from little studies
*Big, important studio paintings such as this one are exceptions, rather
than the rule, in my work. This piece, about as large as I like to work,
developed out of several on-location oil sketches from a horseback trip
into the Sierras of California. The scene really grabbed me and I ran for
paint kit and camera. Weeks later, back at my studio with both sketches
and photographs before me, I simplified out much of the detail and rede-
signed the river to lead into my point of interest. Over the course of the
month it took me to complete this painting, I went back into it many
times, building up textures and working to capture the quality of morn-
ing light on the mountain against the deep blue of the water.*

A Difficult Day at Morro Bay

Today we head out to Morro Bay, a small commercial- and sport-fishing village that hugs the central California coast. Lots of nautical scenes here, with fishing trawlers, pleasure craft, swooping gulls, dockside activities, and distant vistas sparkling in the sunlight.

But for me, this painting excursion turns out to be "one of those days," proving that, even for the professional, not everything is the easy success you might think. My morning begins with not one false start, but two. The third demonstration, while better, doesn't really take life until . . . but I'm getting ahead of myself.

The One That Almost Got Away

Reviewing this demonstration, it's apparent to me that it conveys an important message aside from the one I originally intended. The lesson is this: *You're not the only one who has difficulties with paintings.*

Every artist, student or professional, encounters paintings that just don't want to be painted and days when nothing goes right. In that sense, working outdoors is a lot like fishing; even the pros don't always catch something!

There are many reasons this might happen. Sometimes you just don't know enough about your subject. You could be tired, preoccupied, not feeling like painting, in a lousy frame of mind, or simply having a bad day.

Few things are more frustrating than trying to push a painting that's going badly. My advice? Stop. Wipe it out, start over, reorganize your studio, clean out the garage, or curl up with a good book. Don't sweat it. You're not alone, and it's not the end of your painting career.

On the pier at Morro Bay

Morro Bay, take one

On the pier at Morro Bay, I set up my easel, with the dock and a grouping of small boats before me. Freshening my pigments, I tone an 11″ × 14″ wood panel and begin.

There's a lot in this scene. I try to simplify it to the two boats at center backed by the dock, quickly sketching them onto my panel. I scrub in highlights, but pause, unexcited by the composition and unhappy with its complexity. I wipe it out to begin anew.

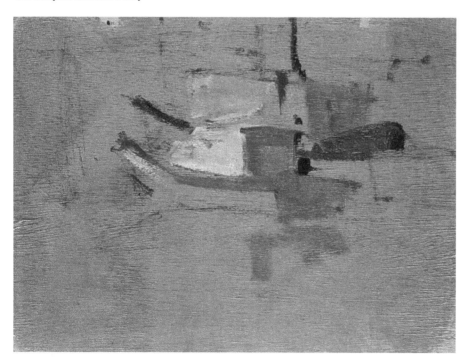

First attempt

Morro Bay, take two

I decide to try it this way: a single boat against the dark forms of the pilings. Instead of drawing the whole scene, I simply lay in a shape representing all the middle-to-dark values.

I punch out highlighted areas with white and light grays. Without much regard for what's actually there on the dock, I begin breaking the large background mass into more interesting and varied geometric shapes.

I'm still not getting excited about this subject. I'll walk around and see if there's something I like better.

Take two

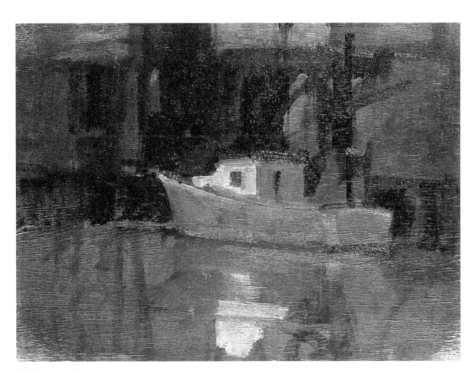

Still struggling

Morro Bay, take three

OK, now I see my subject. Look south at the distant headland, almost silhouetted in the sun. Boats and buildings clustered on the shore. It looks complicated, but watch how I simplify it.

My composition will be a "horizontal parallel bar."

Taking another look around

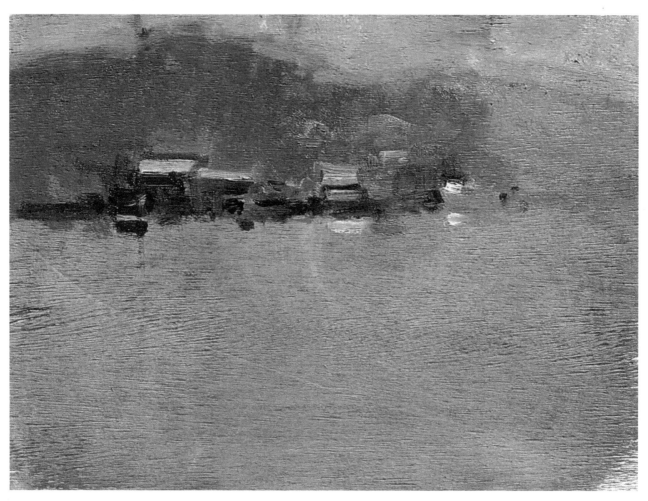

Step 1. A distant harbor view

Before putting in any detail, I'll paint the land mass as a single big abstract shape, using a grayed-down mix of viridian and raw sienna. Adding some white to that mix, I scrub in the far distant land mass at extreme right. Then I add still more white and use that for the sky. Three values of the same color will always work together.

Notice how soft I keep the edges between these shapes. They are outside the point of interest; I don't want the eye to focus on them.

The overriding principles here are (1) get the big shapes down first and (2) go back to refine them. That's really what painting is all about.

Most of the colors I add along the horizon are middle values, very grayed because they're far away. That will make my accent colors pop more. I keep all the building and roof shapes very simple, alternating light and dark values.

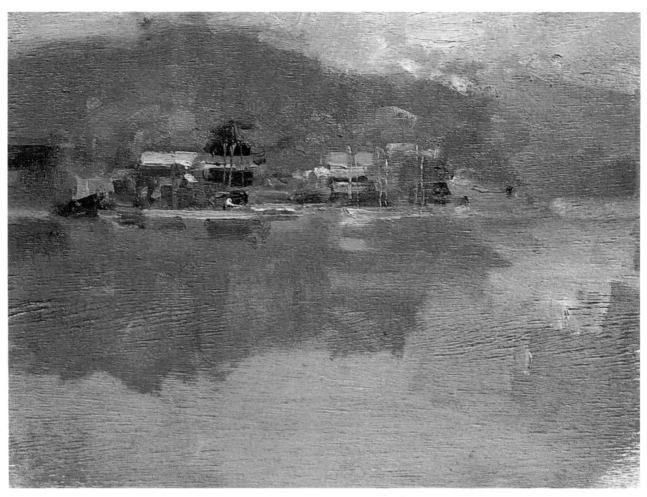

Step 2. Imagination takes over

I add touches of viridian in the rooftops, suggest sailboats along the shore with fine white verticals and horizontals, work warmer green into the land mass (still breaking up that big shape to add interest), and try a spot of intense color—cadmium red light—near center. *That* I like. I also lay in the reflection of land mass and sky, a mirror image that's a little grayer and cooler than what it's reflecting.

WHAT DO YOU HAVE TO LOSE?

Sometime, when you have nothing in progress and don't want to start a new painting, rework one of your unsuccessful old canvases. Every so often I do just that.

You might warm it with an earth tone or a mixed-color glaze . . . or cool it with violet, blue or green. What the glaze does is to introduce a common color that tends to unify the painting.

What do you have to lose?

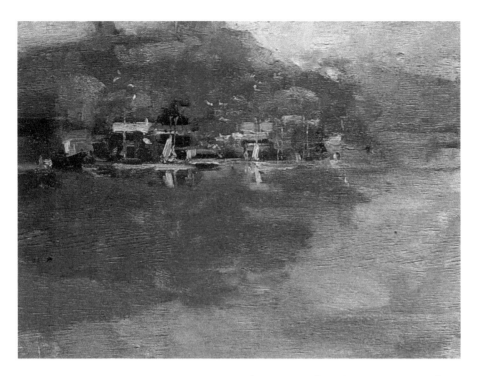

Step 3. Looking for the "lift"

As I'm working, I look for that little uplift of excitement that tells me the painting is on its way. It may come while laying in a particularly satisfying passage, or even when I add just a spot of color. If that lift of excitement never strikes me, I know the painting won't excite the viewer either.

I define the shoreline with strokes of light, elaborating a bit more on the sailboats. I also carry some point-of-interest colors down into the reflections.

The painting is beginning to take life. A few sea gulls swooping around the shore add a little staccato movement. Is the painting finished? Not yet. I'm still waiting for that "lift." What should I do next? Nothing.

Ultimately, Ted realized what had been happening to him on the dock that day. To understand, you'd have to have known Buck. A constant companion at every workshop, "Bucky" was Ted's big, gentle, lovable yellow Labrador Retriever. The two went everywhere together, and there was a potent bond between them. On location, Buck would go exploring, then curl up and watch worshipfully as Ted conducted his class. Buck was only two-and-a-half years old when he was diagnosed with cancer. Ted nursed him along for nearly two years before his good friend became too ill to carry on. Buck's last outing, only a few months previously, had been at a workshop at Morro Bay. Without being consciously aware of it, the big dog's presence, and Ted's sadness at his loss, had returned that day to haunt the artist.

—L.B.L.

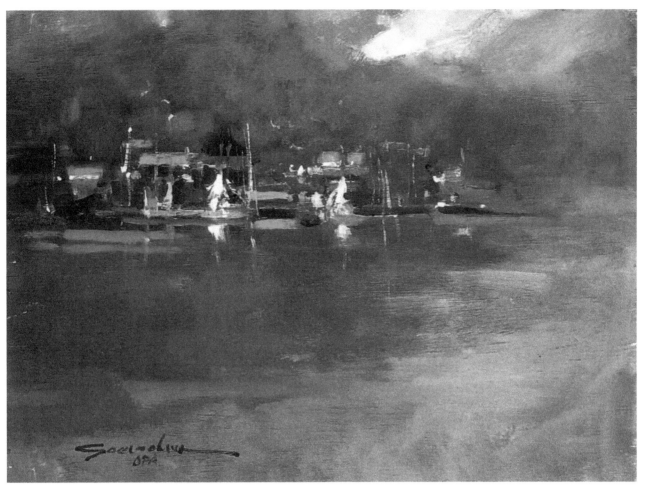

MORRO BAY VISTA
oil on panel, 11″ × 14″

Step 4. Kill it or cure it . . .

Let's see what can be done. I can work over the now-dry paint film without disturbing it, so I'll use a glaze of burnt sienna thinned with solvent to warm the whole painting. I scrub this transparent "wash" over its surface, then selectively lighten by wiping out. The glaze dries quickly.

Now I'll paint directly back into it, picking up highlights and adding some spots of broken color . . . a bright orange roof, white boats and masts, touches of red and viridian. A suggestion of blue in the sky gives the feeling that the weather is clearing. I scumble white into the clouds, then brush pale gray into the water for reflected sky light.

Aahh! Now it's beginning to take flight. More masts for boats, a slash of alizarin crimson across the shoreline, and broken color in and around the horizontal point of interest. Warm neutral gray scrubbed across the hillside seems to suggest low-floating clouds.

At last the painting tells me it's finished. With relief, I add my signature. Not an easy demonstration, but these kinds of struggles do happen, and you might as well know about them.

WHAT'S BUGGING YOU?

Are you bothered by bits of vegetation and insects that fling themselves into the paint film when you're working outdoors? Ignore them as much as you can. A few days later, when the paint has dried, they'll brush off easily.

Paint-On Critique

This is a pretty good painting, but it's showing a whole lot of ocean. I'd crop it right across the shoreline, then pull the stream all the way over to the left side and make it a little wider. That would bring the viewer into the painting nicely.

ARTIST
Gordon Morez

BEFORE

This entire area doesn't function

AFTER

Darker shadows in the
sand focus attention
higher up

Stream is now a natural
entry into the painting

Contrasting horizontal
streaks in water make it
appear wet

Anything Is Paintable

As I'm walking past the fish market, getting ready to leave the pier at Morro Bay, inspiration strikes. Laid out before me are all manner of fish: fresh, sparkling, colorful and beautiful!

A well-iced display of red rock cod, with their huge eyes, great gaping mouths and brilliant color, catches my eye. Now wouldn't a couple of these make an interesting painting? I purchase two and head back to the studio at Cambria, where we reconvene for an afternoon of piscine painting.

The subject is . . . painting!

As I've mentioned, all subjects are painted the same way, so subject matter should be irrelevant to the artist. Whether it's the Grand Tetons, a bowl of fruit, or even a couple of fresh fish, the methods and approach are the same.

With these subjects, I would like to play up their beautiful contours, as well as the expressiveness of their eyes and mouths. I'll take some time to arrange the fish in a way that looks natural, yet pleases my compositional sense. One has to be dominant, the other subordinate. The background should be whatever best complements the fish, so I'll develop it as I go along.

Step 1. Color and proportion, right from the start

Working on a 9″ × 12″ toned wood panel, I'll draw my subject with a mixture of cadmium red, cadmium orange and alizarin crimson to capture the rich red tones of these cod. On a painting like this, light and color can be used to place the focal point wherever I want. The important thing to me right now is making sure the proportions are natural looking.

Step 2. Making choices

Just as with any other subject, you should push color even brighter than it appears. Look at the cadmium orange I've brushed into that top fin and tail. I won't concern myself with the speckled texture of the fish, except for a few highlights to suggest it.

There are two ways I might go with the background. The deep warm approach would give the painting a somewhat monochromatic color scheme; the complementary approach would bring touches of greens and greenish neutrals into it. Unsure yet of which way to proceed, I hedge by scrubbing in some dark reds at top left center, moving that color toward violet at the left corner.

I'll key in my dark values now: the fish's eye and the dark of the open mouths. Contouring the fish itself, I lay in a fairly dark red along the upper edge, then transition it through cadmium orange to cadmium yellow, ending with a high-chroma yellow-white along its belly. This is getting exciting! Notice the delicate shades of violet on the underside of the jaw? Manganese violet and white for that.

Working again on the background, I experiment, mixing a greenish neutral of sap green and burnt sienna, and work that into the maroon and violet already in place.

SOMETHING FISHY

If you're going to pose fish under lights, or for a few hours, don't plan on serving them later. They won't stay fresh very long, even under the best of conditions. Once you accept that they are subjects for painting, not dinner, keep them looking fresh and wet for hours by brushing or spraying on a light coating of mineral oil, cooking oil or even paint solvent.

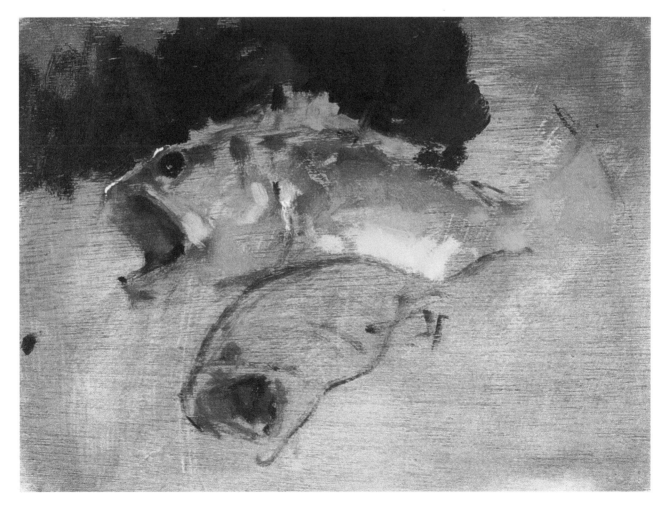

Step 3. Bringing up background and subjects

The palette for this painting is fairly simple: analogous, ranging from cadmium yellow light through cadmium yellow medium to cadmium red light, touches of complementary green and bits of violet in the background.

I'll spend some more time on the background, extending it both left and right around the perimeter of the painting, watching how it works against the subject at each area, varying color as I go, softening edges here and there.

At the same time, I'm not neglecting the fish, working on the graded hues around the body and adding color to the secondary fish. Highlights of bright cadmium orange and cadmium yellow light mixed with white begin to spark the glossy texture of my subjects.

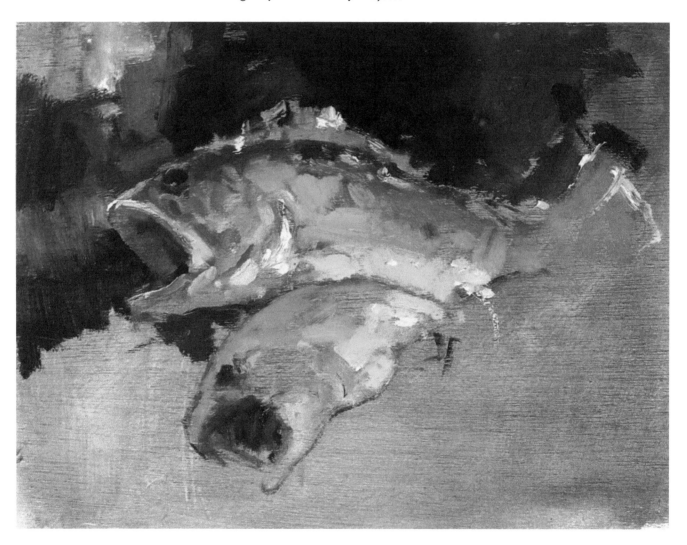

THE SIXTY SECOND MICROWAVE MENTALITY

Today, we live with what I refer to as "the sixty second microwave mentality."
If it can't be done in a minute, it's not worth doing. That doesn't go for painting.
 I've been pushing paint for almost forty years and have made just about every mistake possible. I'm still really just beginning to understand what painting is all about and that it's worth the time put into it.

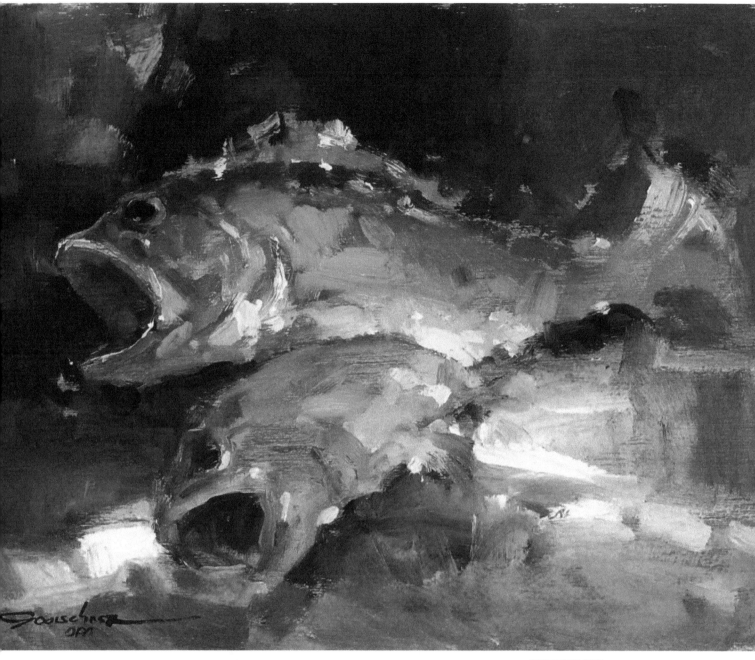

Step 4. Color complements and sparkle

RED ROCK COD
oil on wood panel, 9″ × 12″

Keep background simple. Add some viridian in the upper left, then blend it in. See how nice that little complementary touch looks?

Light, cool shadows in foreground, keeping edges soft so as not to emphasize them. White in right middle ground, cobalt and white, a good color to contrast against the yellows and oranges, for shadows. A hint of highlight yellow in right foreground.

I'll allow some of the panel value to show through; there's no disgrace in that. Some of the foreground blue is moved into other areas of the painting: to the background and also as a highlight just left of the fish's tail. Finishing touches include a few more highlights, edges, and dots of broken color. It's finished!

Paint-On Critique

This painting was started right; it just needs completion. The tree mass at right has to become a huge dominant mass. I'll move the point of interest in a bit without disturbing that house, creating a "horizontal parallel bar" moving the eye through the picture from side to side.

ARTIST
Hope Amme

BEFORE

House is too close to the
edge to be a good point
of interest

AFTER

Pure ultramarine in
darkest-shadowed
foliage for maximum
contrast

Sky holes lighten trees

Extend tree mass off the
panel at top and right

Varied greens within big
forms

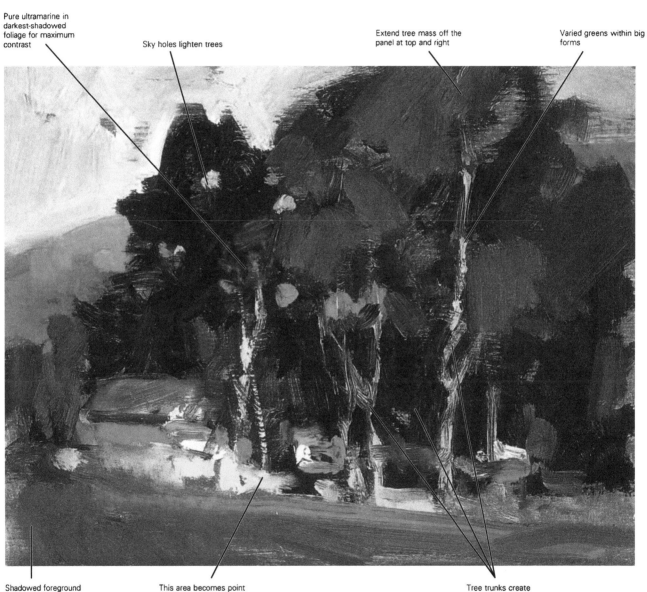

Shadowed foreground
moves focus upward

This area becomes point
of interest as I add
brightness and color

Tree trunks create
negative spaces to work
darker values into

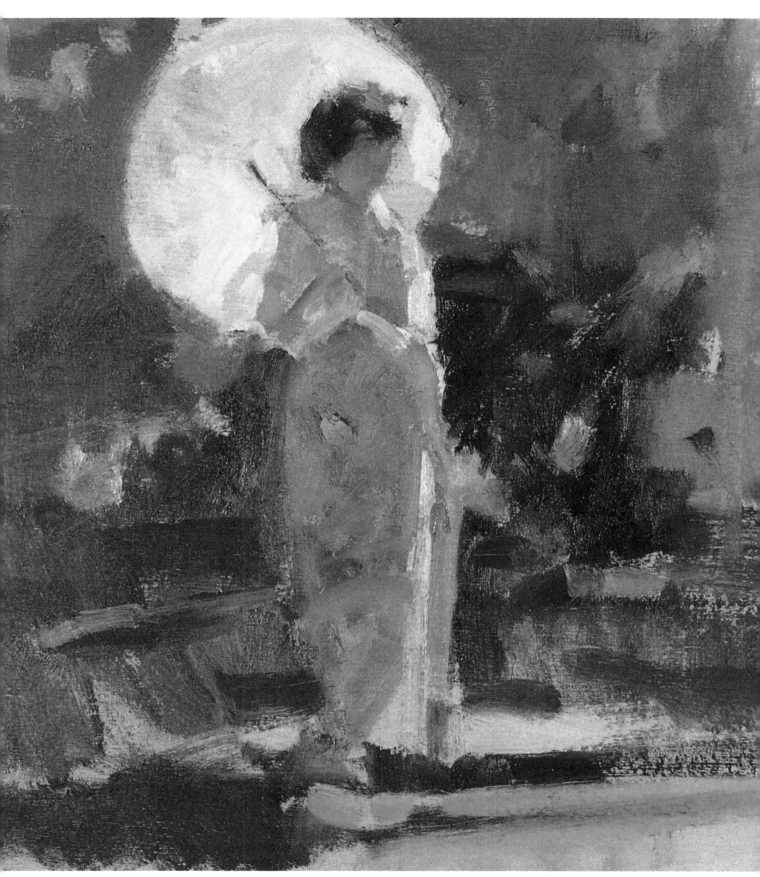

GIRL WITH PARASOL
oil on panel, 9″ × 12″

The figure paints its own background
*Small figure studies painted outdoors are not only delightful, but great practice and fun
to do. Here my subject is backlit from upper right. The light shines through her parasol,
while face and body catch light from the right. Most of the figure is in shadow. You'll find
lots of neutral colors in those shadows. This is a classic example of how the figure paints
its own background. Whatever the figure needs, you place around it.*

Adding Life to Your Paintings

There are those who feel that figures impart life, giving the viewer of a painting someone to identify with. On the other side are those who'd just as soon leave people out.

I prefer my landscapes unpopulated. Yet a cityscape without *any* people has a very eerie feeling about it.

For today, to keep both camps happy, I'll include a studio demonstration for each: an unpopulated yet full-of-life California landscape and a well-peopled market scene from Venice, Italy, that liveliest, most paintable city of all.

Punching Up the Point of Interest

Now I'd like to show you how *everything* I do is designed to make my point of interest the most important part of my painting. You'll see how using grays for shadow and distance helps achieve that objective.

My subject is a fairly typical California farmhouse, with its oxidized copper roof, situated in wide vistas of rolling countryside. The subject itself is not important; the way that I deal with it is.

Begin with a plan

Don't start painting "hoping" you'll find a point of interest. Establish it first, then do everything you can to emphasize it. My point of interest is a house, placed high and to the right. My composition is a combination "steelyard" and "golden section."

Start with the point of interest

The house pops with bright sunlight on its near face. I frame it with large, dark tree masses, keeping values strong . . . concentrating interest in that top right quadrant. Even my background mountain peaks there. All my darkest darks, lightest lights, hardest edges, dominant masses and strong contrasts are focused in that one region. This all has to be planned at the start; it won't just happen. You have to take control and *make* it happen! I usually establish my brightest lights and my darkest darks right away, building out from there.

Background as backdrop

Backgrounds function when they support the point of interest. Here, my distancing violet-grays come into use: mixed with viridian and ultramarine for the distant tree line, cobalt blue and white plus a touch of magenta for the mountain, and terra rosa to suggest roofs in the distance.

Keep the foreground simple

What the foreground must *not* do is take away from the point of interest. That means painting everything in middle values. I'll be basing it on shadowed hues achieved with my muddy grays. Warmer and cooler. A bit more color here or there. The pathway is painted in middle values, too, of warmer earth tones.

I pull some light across the road at the rear, Naples yellow and white, and green where it crosses the grass at right.

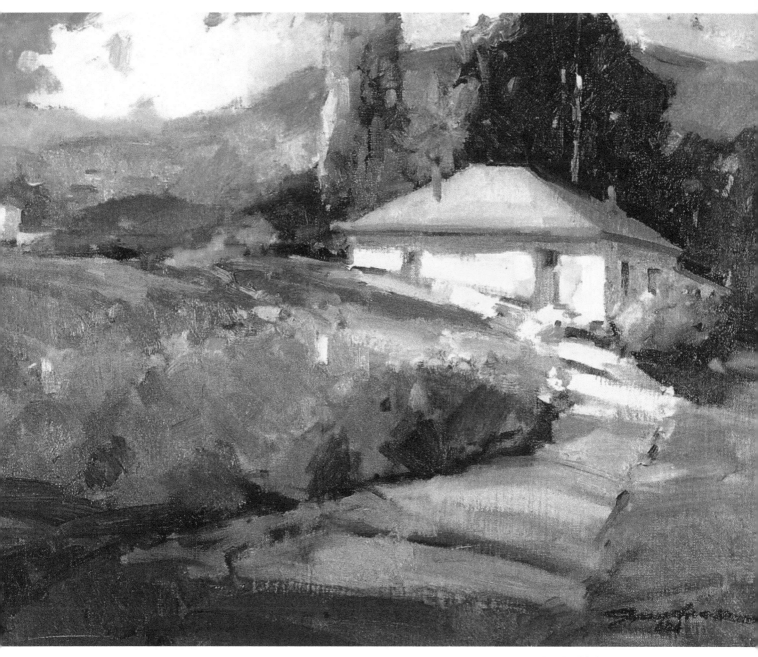

NEW MEXICO CASITA
oil on canvas, 18″ × 24″

I also add touches of broken color. Little spots of unexpected brightness create vibration and excitement: red around the house, bright yellows, pinks and greens in the foreground, and violet in the trees at right. Cadmium orange, yellow and other broken color in the trees, a few more touches here and there . . . you'll easily spot them. A light manganese-violet glaze thinned with solvent builds interest to the left of the road. Everything is designed to emphasize the point of interest.

LAY IT DOWN AND LEAVE IT

The freshest paintings are done with a minimum of brushstrokes in each area. I know it's an ideal, but try to lay it right down and leave it.

Paint-On Critique

The best thing this painting has going for it is the beautiful lead-in through the foreground. But it lacks punch. This painting will benefit from a great deal of brightening, simplification of shapes, and a bold emphasis on that tree, the obvious point of interest.

ARTIST
Virginia Weick

BEFORE

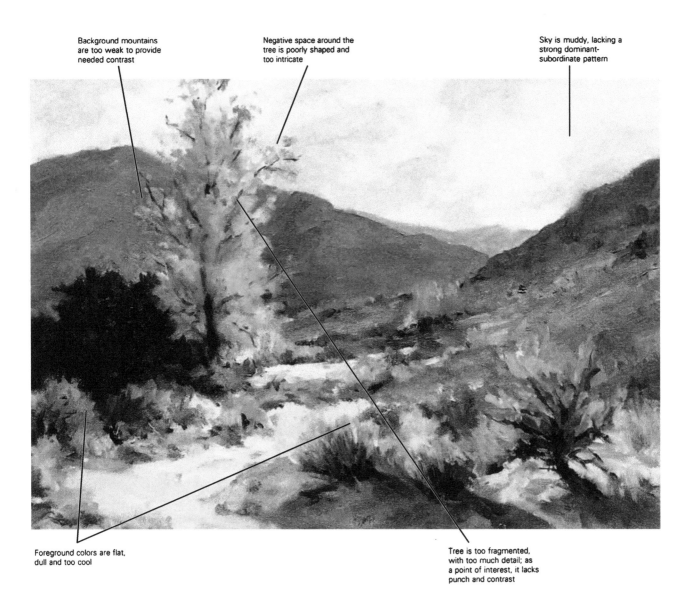

Background mountains are too weak to provide needed contrast

Negative space around the tree is poorly shaped and too intricate

Sky is muddy, lacking a strong dominant-subordinate pattern

Foreground colors are flat, dull and too cool

Tree is too fragmented, with too much detail; as a point of interest, it lacks punch and contrast

AFTER

Mountain darkened, changed to blue-violet for complementary contrast with tree

Tree has been simplified and brightened analogously to put it into sunlight

Pattern of puffy clouds in deeper-blue sky

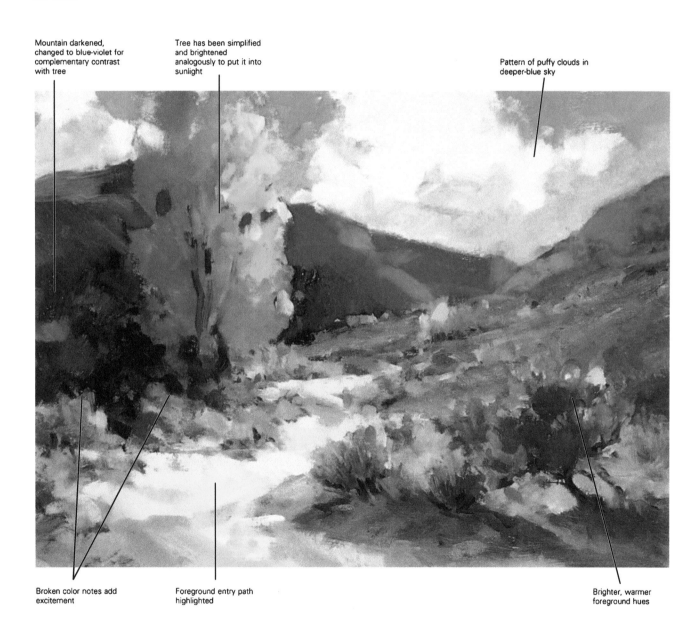

Broken color notes add excitement

Foreground entry path highlighted

Brighter, warmer foreground hues

Painting a Subject With People

Many times a student will decide nine-tenths of the way through a painting that "it needs some people." Then he'll wonder why the finished piece doesn't work. Maybe I should call this section, "How to *successfully* put people in your paintings."

The moment you put a figure into a painting, it becomes the center of interest. If a painting already has a focal point and it isn't near the figure, you've got problems. The composition should really be planned with figures in mind.

Because the figures you paint grab the eye, everything around them, especially the immediately adjacent areas, must be planned to support and accentuate them. Like it or not, they're the point of interest! That's what I mean when I say, "the people paint the picture."

Look at this photograph I took in Venice a few years ago. What a beautiful place! A painting around every corner. This is a market on a piazza beside the Grand Canal.

Step 1. Planning the composition

Start by wiping on a neutral midtone: Venetian red. How appropriate! Next, since this is a fairly complex subject, I rough in my composition before blocking in masses. To simplify the arches, the market scene is framed within one major arch, with a subordinate column and hints of other arches a little way back. Though not readily evident at this point, my compositional device is based on the "horizontal parallel bar."

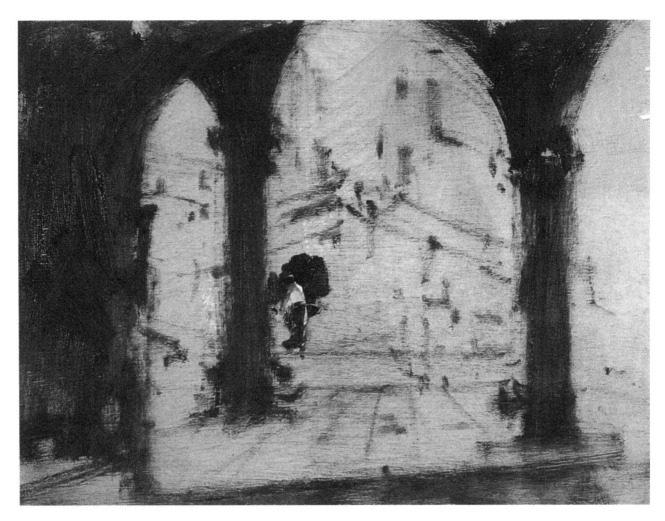

Step 2. Blocking in masses

The next thing is to block in the big, dark masses—the arches. Just scrub them in, not concerned with shape. I'm keeping the largest mass to the left, with uneven negative spaces at right. Value is what's important here. The bases of the columns establish the ground plane. The dark shape at bottom—a step, perhaps—halts the sweep of the perspective. It's angled for interest.

THE FIGURE PAINTS THE PICTURE!

That's all preliminary; I'm really starting with the key figure. He'll contain the lightest and darkest areas in the painting. I place his white shirt against a dark background to make him pop.

All of this comes before deciding exactly what's going on behind the main figure! The key figure paints the rest of the picture!

The shadowed side of his shirt is my blue-gray neutral. A touch of white on the shoulder, spots of fleshtone and black, tiny highlights, and dark sienna all around to frame it. Notice how the background goes red toward the top so the black shows up.

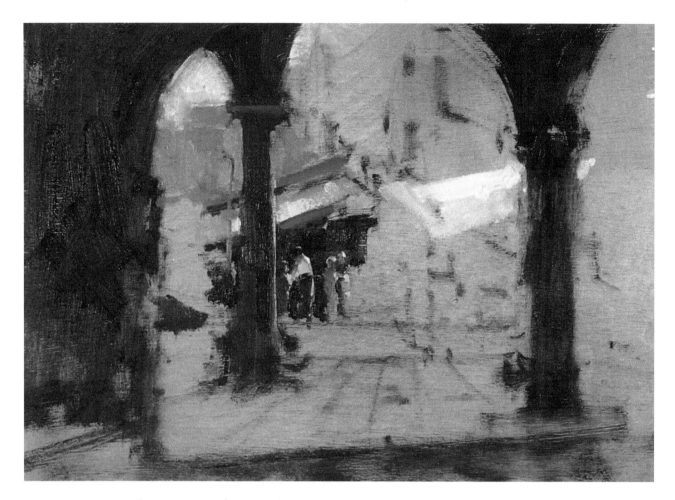

Step 3. Working out from the center of interest

Now begin working away from the main figure. I put a glowing yellow high-
light above the red and refine the right edge of the pillar, creating a highlight
against the dark background with a very subordinated person in blue against
that. The orange figure is laid in, catching a highlight atop the head, working
the dark background toward the right, and adding more figures, one after
another, to the left of the pillar and to the right of the orange. The effect of
the figure to the left of the pillar is to pull the middle ground through behind
the pillar, lending depth and continuity to the evolving scene.

Begin applying some finished values to the background and other areas.
It's necessary to begin bringing the painting up all over, which also gives
me time to develop the scene in my mind.

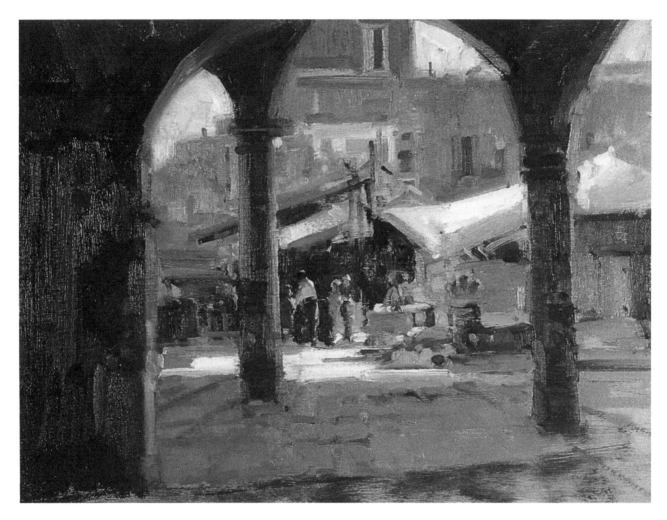

Step 4. First the stars . . . now the stage

Give the people a horizontal plane to stand on, while playing with the shapes outside the center of interest, highlighting some and downplaying others. Do all this without pulling attention away from the center of interest.

Extend the middle-ground market scene left and right, subduing contrasts, softening edges, being careful that lights and darks do not compete with the center of interest. The farther I get from that center, the softer the contrasts, colors and edges. The shapes of the foreground arches are defined and interest is added with color and value changes within the masses.

The flagstone lines, subdued with neutral violet-gray for a light-filled shadow value, move the viewer's eye back to the center of interest. This also gives me the opportunity to brush a brilliant light streak across the middle ground, emphasizing, without overpowering, the contrasts in and around my people.

ONE POINT OF INTEREST

Students often fall in love with more than one area on a painting and start to spend too much time on it. They end up with *two* competing centers of interest. The rule is: *Nothing can be more attractive than the point of interest.* Keep that in mind, and you'll turn out a powerful painting. Forget it, and you'll end up making wallpaper. There's never a center of interest on wallpaper!

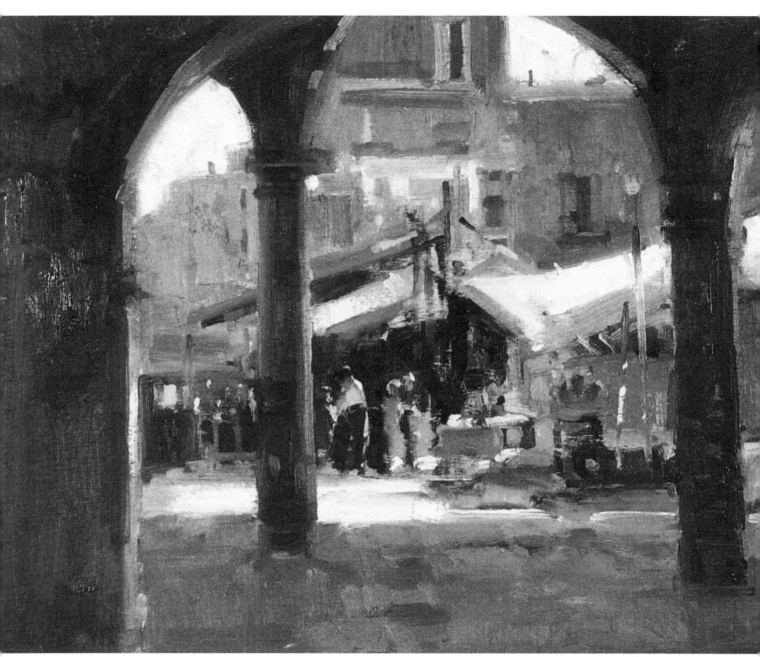

VENICE STREET MARKET
oil on board, 9" × 12"

Step 5. Final details

What happens in the area around the center of interest is important because
it affects that center. Finishing *Venice Market* requires smoothing some of the
textures; adding some reflected lights in the shadowed foreground pavement
(is it wet?); adding broken color throughout the middle ground to create
eye movement; loosely rendering background buildings in a narrow range of
neutral, high-key hues; and adding suggestions of a few poles or pillars to break
up the strong horizontal movement. The subject of this painting is not the
Venetian street market, despite its title. It is the *people* in the market that
make the painting work.

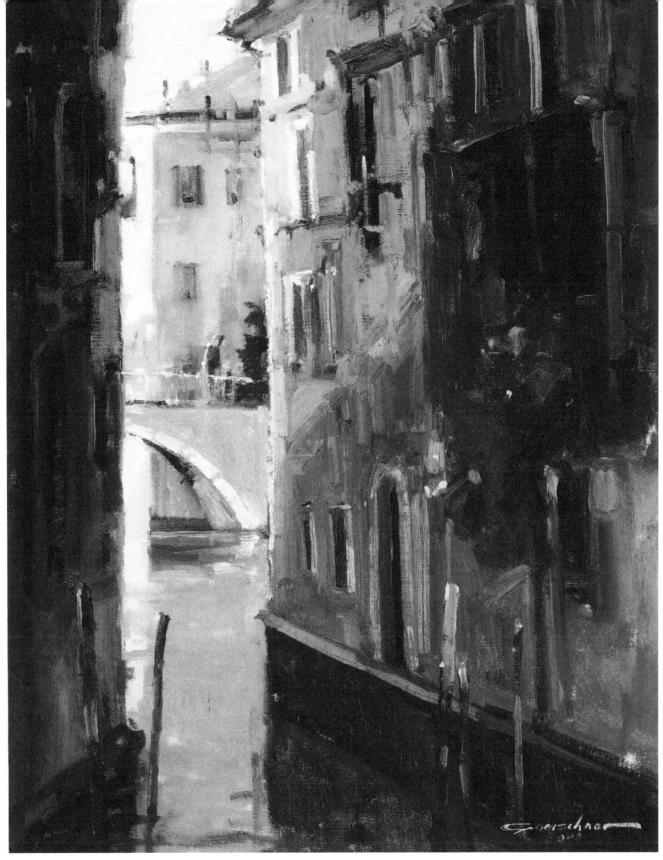

THE WALK
oil on panel, 24″ × 18″

Drama and mystery in Venice
Marilyn and I were seated in a gondola, snapping pictures as we rounded the bends in the little side canals, when suddenly this scene practically blew me out of the boat! The light hitting the buildings, the bridge, the powerful shadows and light, the wonderful geometry. A lone figure supplies the point of interest. Figures always do that. But beware the subject with two separated figures; you may end up with two points of interest!

Paint-On Critique

The figure in this painting is too stiff and upright. Try to give it a little movement. Another problem seems to be too much detail in subordinate forms. Watch as I tie those three dark tree shapes together, at the same time framing the figure more effectively.

ARTIST
Judy Black,
Gainsville, Georgia

BEFORE

These forms are too equal in size and shape; none are dominant

Distant trees are too busy

Foreground shadowed snow is too warm

Tree is too busy

Figure is too erect and stiff

A few quick hints on figures

When laying in figures, place head, then torso and pelvis, extending feet to the ground. The elements are connected by the spine and move in concert with each other. Their shifting angles give your figures movement and life.

Head

Torso

Pelvis

Standing adult figure is eight heads tall

Static pose is uninteresting

Even standing figures can have action!

Moving figures lean into the action

AFTER

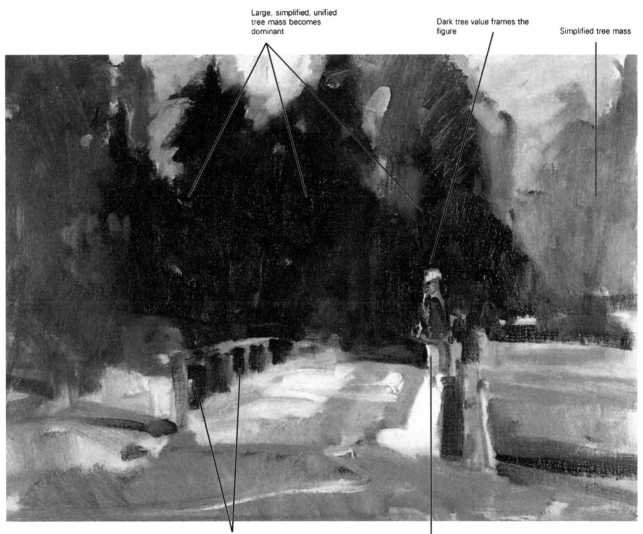

Large, simplified, unified tree mass becomes dominant

Dark tree value frames the figure

Simplified tree mass

Suggestion of tree mass seen through railing

Figure is much more interesting with a little movement

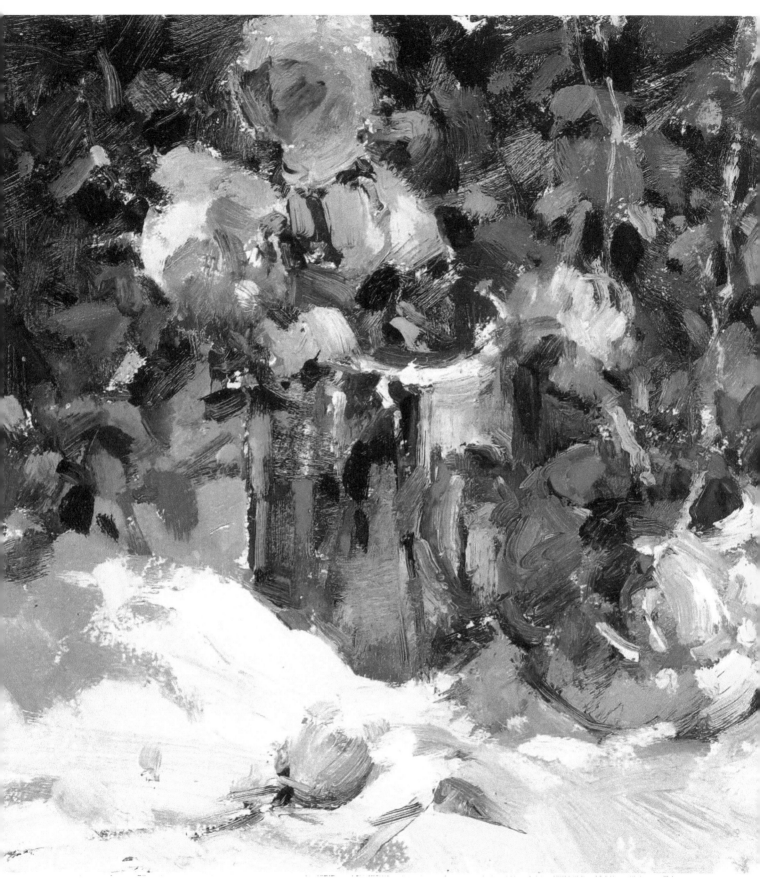

MAGENTA
oil on panel,
9″ × 12″

Tertiary complement

Having just discovered Winsor & Newton's magenta, I fell in love with it and decided to have some fun with this little color exercise. I played red-violet against yellow-green in a complementary color scheme using tertiary colors. You should be doing this kind of small, loose sketch before undertaking a subject in a big painting. On the small panel, you can work out the kind of problems we're dealing with in this workshop, like shapes, arrangements, positive and negative areas and so on, before diving into the biggie.

Designing Your Paintings

We set up this morning in a shady grove above the beach, facing a grouping of houses peeking from a similar grove just across a small creek. Nature has provided a perfectly sunny, though breezy, day. The surf thunders away to our left, and before long devoted sun worshippers, small children and dogs arrive to frolic noisily in the tiny pond some fifty yards below our vantage point.

Our focus today is on the design aspects of painting: learning to think in terms of masses with shape, color and value and not merely filling in the spaces of your drawing.

Think Planes and Masses

When I was in my first year at art school, it was a while before I figured out why they made us study both sculpture *and* drawing. It was so we'd learn to see three-dimensional mass in our two-dimensional drawings.

You may well find it necessary to make a sketch on the canvas before painting it, and that's fine. But if painting is thought of primarily in terms of drawing, it becomes little more than coloring in that drawing. A better approach is to begin to think of the painting process not as "filling in the spaces," but as if you are really manipulating solid abstract masses on your canvas, masses with planes, shape, color and value.

Gradually—first by watching and understanding what I'm doing on these pages and then by painting a lot on your own—you'll learn how to take liberties with shapes, moving them around in a composition, balancing dark against light, large against small, thinking of them as forms the way abstract artists do and not as trees or rocks or buildings.

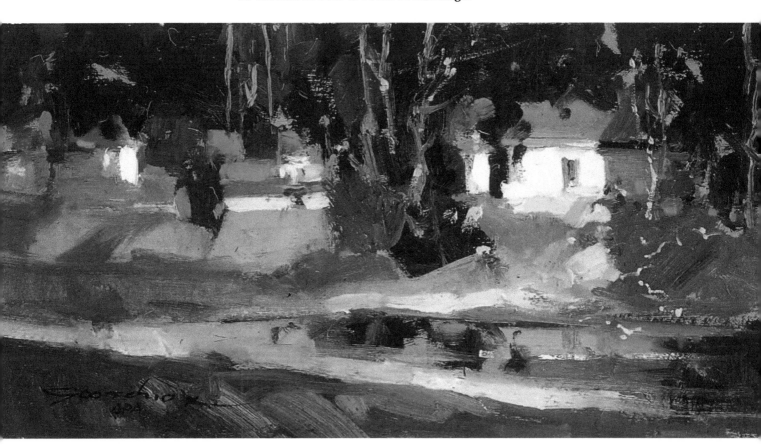

HOUSES AT SAN SIMEON
oil on wood panel, 8" × 16"

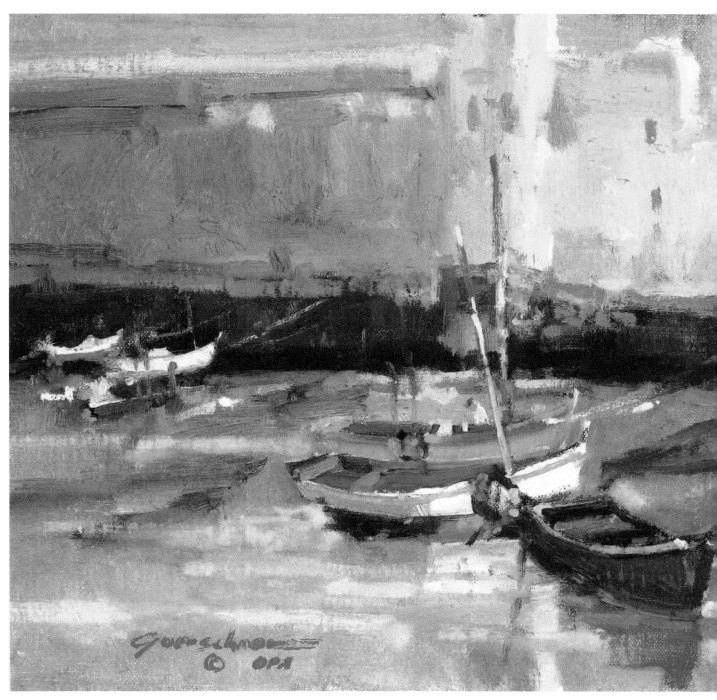

LOGOS LOW TIDE
oil on canvas, 11″ × 14″

A nice visual spin

This scene, harborside in Logos, Portugal, was done from a photograph: a bright, sunny day with lots of reflections. The antiquity and character of these utilitarian boats, in their bright primary colors, make a wonderful subject. The near-abstract pattern of the three boats leads you into the painting. Vertical masts bring you up into the background, then around and down through the smaller grouping at left. A nice spin, leading the viewer in and around the painting. On Day Seven you'll learn more about how to create eye movement in your own paintings.

REFLECTIONS

When you paint reflections in still water, they rarely appear as intense as the actual objects they reflect. A bright white will usually reflect about one shade darker; an intense black will appear as a very dark gray. Colors, too, are slightly grayed.

Paint-On Critique

This painting was made from a photograph of mine, a snowscape through a grove of aspens. It has two key problems: First, the student, perhaps fearing its complexity, has left out almost all the trees. I'd have featured them, with the house peeking through, as a great exercise in negative space. Second, the painting is all in middle values. I'll bring up the trees and the background together, which will help me know what values to use. Let's see.

ARTIST
Jodie Rippy
Wilmington, North Carolina

BEFORE

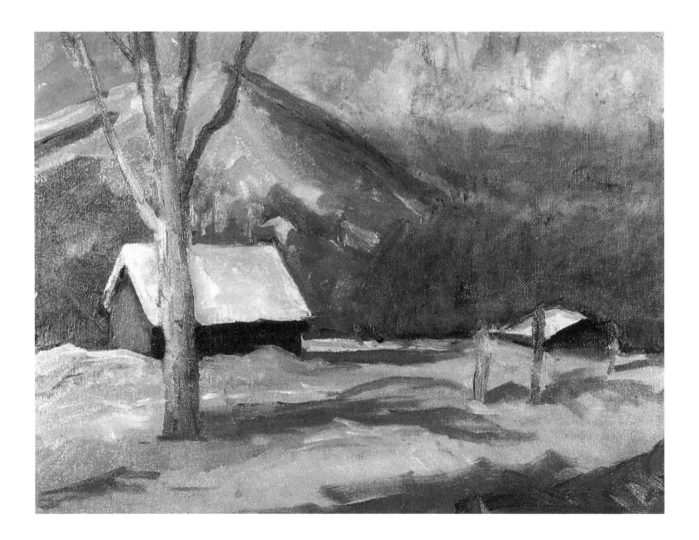

AFTER

Softer whites and
shadows in background

Deep, dark greens in
background around tree
shapes

Brighter colors in house
attract the eye

Birch trees: Scrub in forms
with warm-shadowed
white, add dark markings
and branches and a
highlight along sunlit edge

Simple shadowed
foreground doesn't grab
attention away from point
of interest

Brighter foreground
expands value range

Creating Eye Movement

Throughout this workshop book you've been reading about "abstract design" and how to think in terms of two-dimensional shapes before looking at those shapes as trees, houses or flowers. The way shapes are used determines how the viewer looks at a painting. Eye movements are guided primarily by shapes directing the viewer's attention to the point of interest. Then these shapes invite exploration and discovery of the areas around the focal point, eventually returning to it. This subtle guidance may be seen when you observe someone captivated for many moments by one painting, then glancing only briefly at another right beside it.

Shapes are either dynamic or static. Triangles and trapezoids are dynamic—they move the eye toward a real or implied point. Spheres and squares are static—they just sit there.

When you grasp the importance of these shapes, and utilize them from the very beginning stages of your painting to direct eye movement, you will have understood an important underlying concept of this workshop book.

Building on shapes

I'll demonstrate the use of dynamic and static shapes by beginning quite abstractly and building on them to arrive at a finished representational painting. I've selected this photograph of a New Mexico adobe building with an old wagon in front of it.

Step 1. Shape, and shape only!

Scrub in major shapes first. I've used a mixture of burnt sienna and manganese violet thinned with solvent. The dominant shape is a dynamic "directional" element: a large triangle (the shadowed adobe wall) pointing into a static sphere (the tree mass and shadows at right) that includes the point of interest. Other shapes within these will create movement around the point of interest.

Scrubbing in big shapes with solvent-thinned paint, I quickly drag some out into the lower third of the board, breaking up white space. An undefined form breaks up the too-straight top edge of the dominant triangle, and a smaller triangle at top right center repeats the dominant shape and contributes further dynamic movement.

Step 2. Further defining the shapes

Now I work within these large shapes to define them. Using a no. 3 bright
for sketching, a large circle represents the dominant shape within the greater
tree mass at top right. A smaller circle to its left represents a subordinate
mass within that same area. This is a good example of how large shapes are
invariably made up of smaller ones. Develop your awareness and sensitivity
to them and how they interact.

Some of the elements that will break up the large masses are sketched in.
My focal point is at right center, including the wagon and sunlit wall. At this
stage, I've also begun adjusting some of the values in the underpainting in
preparation for my next step.

Step 3. Keying the composition from point of interest out

Start this stage with the point of interest, establishing the sharpest detail and strongest contrasts. I place Naples yellow and white against the dark green tree mass, which is extended left to back up the bell tower and lightened on its left side to catch light coming from that direction.

Continue to develop the point of interest, backlighting the wagon, laying in the spokes and then punching light through them. I'm not afraid to lose an edge—or even a spoke—here and there. Spots of broken color in and around the wagon add life to the point of interest.

The fence at right has a little violet in it, which contrasts nicely with nearby yellows. Moving left from the center, warm alizarin crimson shadows are laid in on the wall, ending with an undefined squarish shape.

LESS IS MORE

It never ceases to surprise me how little I actually have to put into a painting to make it work and how unnecessary is the task of "perfecting" things. Simplifying . . . distilling . . . it's an endless struggle against the urge to put everything in.

Step 4. Breaking up subordinate shapes

The bush at far left helps break up the shadow form. I lighten its top edge to catch some light and scrub in some more of that same green, for continuity, toward the wagon at right. To do something interesting with that square shadow shape at left, a window is placed there . . . with a blue frame to ward off evil spirits! This is a good time to pull blue-gray and violet-gray through the foreground, creating shadow areas that blend with adjoining shapes, and to begin working back against it from the right with light Naples yellow, pulling some of that highlight through the spokes of the wagon wheel.

The blue of the sky is laid in. Getting rid of that white brings your attention right back to the focal point. I can't emphasize this too strongly: learn to keep your point of interest prime. Break that rule, and you're invariably in the soup.

SHADES AND SHADOWS

Notice how warm I'm making the shadows in this painting. Many students, used to working from photographs, throw Payne's gray into all their shadows, not realizing that photographic limitations make shadows look cold. Go outdoors. See how warm light is reflected in shadows.

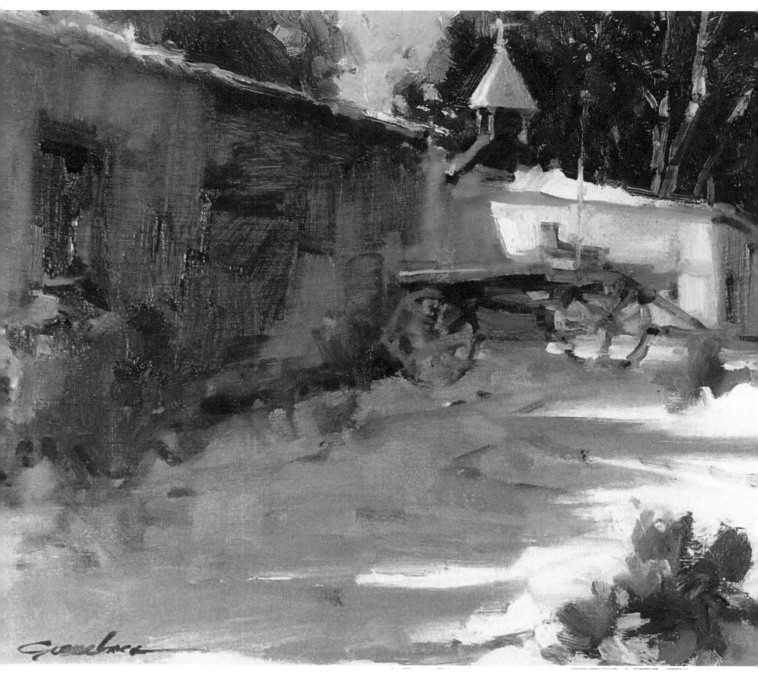

SANTA FE FARM
oil on panel, 12″ × 16″

Step 5. Bringing it all together

The foreground is the next problem. The right is too much of a dead triangle,
so I put a little bush shape in there just for design, then blend it into the
ground with highlight and shadow values. The ground-plane shadows, which
seem to be cast by some unseen objects at left, are further developed; then
it's time to leave the foreground alone.

It's finally time to look at the shapes as objects and move toward the
finishing stages. Add the calligraphy of tree trunks and branches, touches
of light and color in the distant trees—maintaining the dominant dark mass
strong against the subordinate light mass but adding cadmium red in shad-
ows around the point of interest and other touches you'll certainly spot on
your own.

A *last look at the abstract*

The whole theme of this painting hinges on static and dynamic shapes moving the viewer through the painting, and on dominant and subordinate shapes and values playing against each other.

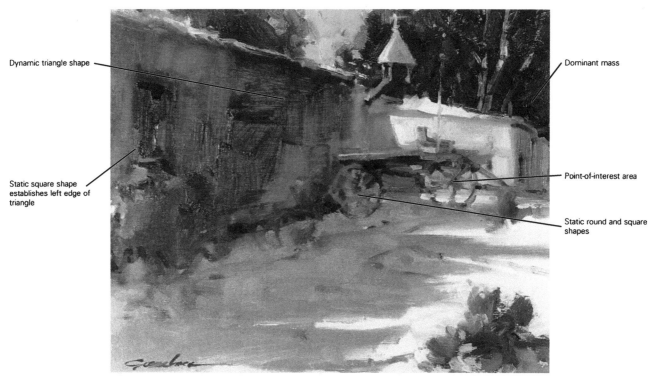

Dynamic triangle shape

Static square shape establishes left edge of triangle

Dominant mass

Point-of-interest area

Static round and square shapes

Dynamic shapes create movement
Here I diagram the shapes and movement in this painting. The dynamic shape is the main triangle at left, pointing the viewer into the circle of the main tree mass and the highlighted wall. The bell tower will move you up, then down again. Other dynamic shapes move you out through foreground and subordinate areas, then back into the point of interest. Notice how the static shapes are all located in the point of interest and how the dynamic shapes lead you around it.

WHEN IS A PAINTING FINISHED?

In the article "In Praise of Painterly Painters," which Charles Movalli wrote for *American Artist Magazine* some years back, he quoted Sir Joshua Reynolds (1723-1792, English) as saying, "A painterly painting isn't finished until the viewer looks at it." Think about that.

Paint-On Critique

ARTIST
Ron Wortham
Roanoke, Texas

T he most-immediate problem in this painting is a compositional one. Notice the large mountain mass and how its direction drains attention from the point of interest.

BEFORE

Tan hue tends to come forward

Contour of mountain pulls attention away from point of interest

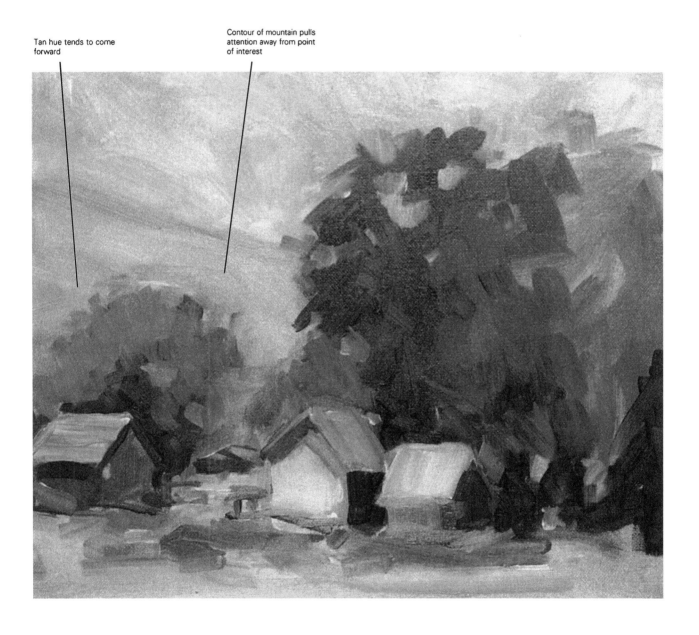

AFTER

Lightened shadows;
house kept subdued to
avoid taking attention from
the point of interest

Puffy clouds in deeper-
blue sky add interest

Reversed mountain
contour to support the point
of interest

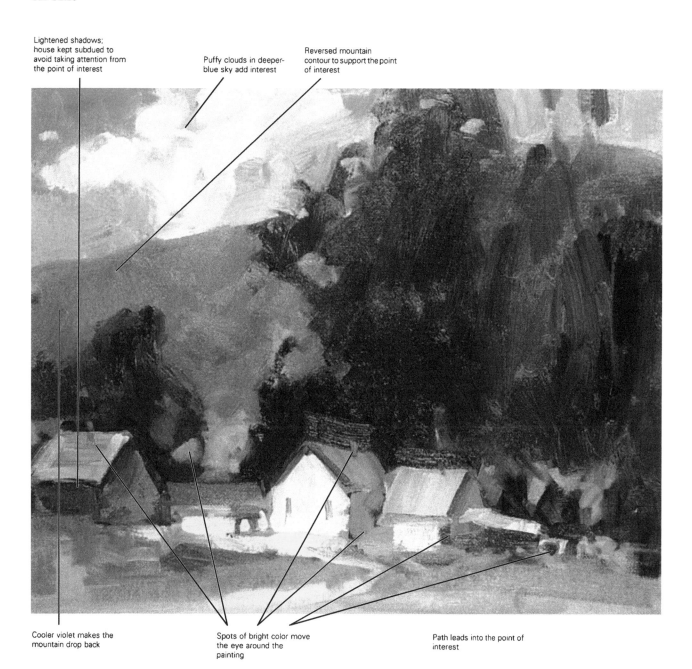

Cooler violet makes the
mountain drop back

Spots of bright color move
the eye around the
painting

Path leads into the point of
interest

A Few of My Favorite Resources

Equipment

EASEL

My preference is for the classic Yarka Russian easel. The easel comes in two sizes; I use the larger one. I also have a Russian parasol with a black liner to keep the sun off my easel and canvas when painting outdoors.

PALETTE

For traveling, I prefer the Easel Pal folding palette. It comes in two sizes. I use the larger model (16″ × 20″), lining the center with a sheet of Plexiglas to lay out and mix paints on because it cleans up easily.

PAINTS

My preferred brand of paint is Utrecht. I am also fond of Winsor & Newton's Indian yellow, magenta and manganese violet.

BRUSHES

I primarily use good, resilient bristle brushes that spring back into shape after taking a beating. Among my favorites are the Grand Prix line. I prefer mineral spirits as my solvent and cleaner.

VARNISH

For varnish, I like Kamar, by Krylon, which is available in aerosol cans. The modern successor to Damar, it restores the sheen to drying areas that have gone flat and serves as a good final varnish as well, remaining flexible and clear.

Books

The Artist in the Real World, Frederic Whitaker, North Light Books, Westport, CT, 1980.

Carlson's Guide to Landscape Painting, John F. Carlson, Sterling Publishing Co., Inc., New York, 1929. Reprinted in paperback by Dover Publishing, Mineola, NY, 1973, and by Peter Smith, Magnolia, MA, 1984.

The Art Spirit, Robert Henri, Harper & Row, New York, 1923. Reprinted several times in paperback by Harper & Row.

Composition of Outdoor Painting, Edgar Payne, published by Edgar Payne, 1941. Reprinted by De Ru's Fine Art Books, Belle Flower, CA.

Nicolai Fechin, North Land Publishing, Flagstaff, AZ, 1975.

Joachin Y Bastida Sorolla: The Painter, P. Wilson for Sotheby's Publications, distributed by Harper & Row, 1989.

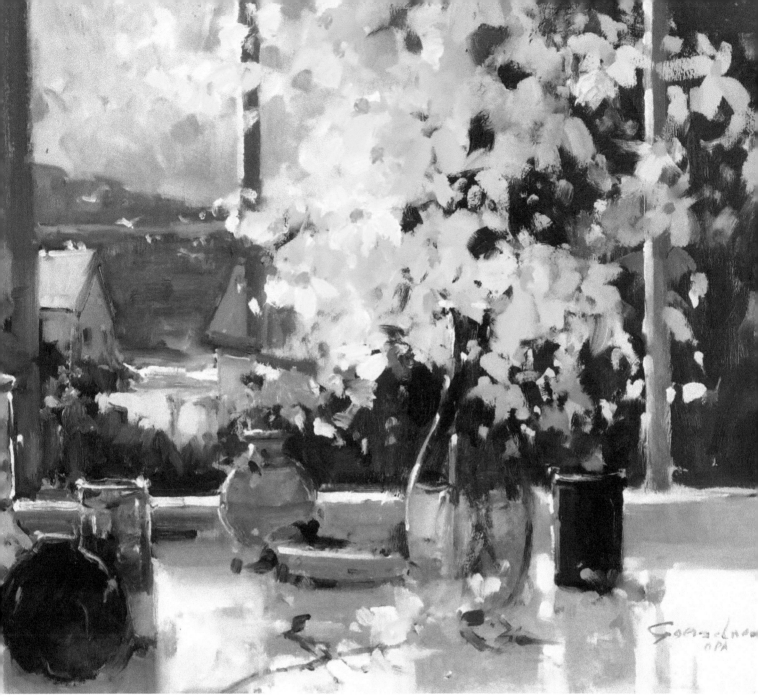

MORNING HARBOR VIEW
oil on panel, 18″×24″

A Final Word

If you've been to workshops, recall that final-day feeling: paintings completed, brushes cleaned, palettes scraped, preparing for return to the real world. That feeling is inevitably made up of eagerness to use newly acquired insights, hope that you won't forget what you've learned, and the faint, sweet regret that the sessions are now history.

You have a distinct advantage with this workshop. Remembering everything isn't a problem because this workshop can be revisited. Perhaps one day we'll meet again. Until then, keep painting!

—Ted Goerschner
July 1994

INDEX

A
Abstract, defined, 17
Accents, adding, 82-83
Analogous color scheme, 9

B
Background, 56, 102, 108
Black and white, 16
Blocking in, 18, 77, 85, 113
Books, recommended, 134
Brushes, 26
 and paint, handling, 27-30
 recommended, 134
Brushstrokes, 26

C
Calligraphy, defined, 17
Canvas. *See* Surface, painting
Center of interest, 49
 beginning with, 108
 defined, 17
 keying composition from, 128
 saving, for last, 48
 sole, 115
 working around, 63
 working out from, 114
Chroma, defined, 17
Color
 adding, 20, 47
 finishing touches of, 65
 and proportion, 100
 pushing, 84
Color schemes, five basic, 9-11
Color wheel, 8
Colors
 mixing, surface for, 7
 spectrum, 16
Complementary color scheme, 11
Complementary colors, 17, 103
Composition
 keying, from center of interest out, 128
 planning, 112
 sketching, 68
 types of, 31-33
Concept, beginning, 44
Contrast, defined, 17

D
Depth, creating, 21
Dominant and subordinate, defined, 17, 37

E
Earth tones, 16
Easel, 6
 recommended, 134
Edges, 17
 softening, 88
Eye movement, creating, 126

F
Focal point. *See* Center of interest
Foreground, 57
 simple, 108
 solving problems in, 38
 and tree trunks, 64
Form, defined, 17

G
Glaze, reworking unsuccessful painting with, 95
Grays, 14, 16

H
Harmony, defined, 17
Highlights, creating, traditionally vs. analogously, 12-13
Hues, exploring values in, 15

L
Lay-in, initial, 37
Light pattern, establishing, 46
Local color, defined, 17

M
Mass, dominant, establishing, 84
Masses
 blocking in, 18, 77, 85, 113
 and planes, 122
Middle ground, developing, 38
Monochromatic color scheme, 9

N
Negative space, defined, 17

P
Paint, on brush, handling, 27-30
Paint-on critique, 24-25, 42-43, 50-51, 58-59, 66-67, 72-73, 98-99, 104-105, 110-111, 118-119, 124-125, 132-133
Painting
 difficulty with, 92-94
 outdoors, 60
Paintings
 successful, keys to, 76-83
 unsuccessful, reworking, 95
Paints, recommended, 134
Palette, 6
 recommended, 16, 134
Pigments, squeezing out, 6
Planes
 laying in, 62
 and masses, 122
Planning, importance of, 76, 84, 108
Point of interest. *See* Center of interest
Positive space, defined, 17

R
Reflections, 123

S
Scene, building, 36-41
Shadows
 creating, traditionally vs. analogously, 12-13
 and shades, 129
Shapes
 abstract, 131
 building on, 126
 defining, 127
 developing, 78-79
 distant, 56
 and forms, working with, 87
 refining, 39
 relating, to each other, 80-81
 subordinate, breaking up, 129
 working within, 21
 See also Masses
Sketching, 61
 composition, 68
Source material, 36, 44
Split complementary color scheme, 11
Surface, painting, 7

T
Triadic color scheme, 10

V
Values
 and contrasts, 86
 defined, 17
 laying in, 62
Varnish, recommended, 134

CPSIA information can be obtained
at www.ICGtesting.com
Printed in the USA
LVHW070833050721
691871LV00036B/2656

9 781626 548558